HIDDEN
HISTORY
of
LONG
ISLAND

HIDDEN
HISTORY
of
LONG
ISLAND

Richard Panchyk

THE
History
PRESS

Published by The History Press
Charleston, SC
www.historypress.net

Front cover: Library of Congress.
Back cover, top: author's collection; bottom: Library of Congress.

First published 2016

Manufactured in the United States

ISBN 978.1.46713.627.3

Library of Congress Control Number: 2016953389

To Elizabeth, the perfect walking companion on my hidden history adventures.

CONTENTS

INTRODUCTION

Hidden History of Long Island weaves together a colorful historical tapestry from the scattered remnants of Long Island's past. Each strip of fabric tells a unique part of the story of Long Island's rich and fascinating existence. Inside this book you'll encounter ancient cemeteries, long-forgotten places and eerie, mysterious spaces. Explore further and you'll discover tales of abandoned mansion ruins, lost pirate treasure and record-setting aviators. You'll be treated to a glimpse into the eccentric minds of some of Long Island's most influential residents.

It was a misty, leaf-strewn autumn day just after I'd started to write *Hidden History of Long Island,* and I found myself standing on a well-preserved section of the old Long Island Motor Parkway in Alley Pond Park, looking to the east. Little did I know it then, but this vintage roadway, begun in 1908 and abandoned in 1938, was to be my companion as I wrote the book. In the course of many other adventures over the months that followed, I would visit the parkway's various remnants on numerous occasions.

The Motor Parkway, the world's first limited-access concrete highway, was not only itself a fascinating piece of hidden history, it was my constant reminder of what this book is about—a ghostly path connecting so much of Long Island's vanished past. The highway's remnants exist in small fragments scattered across what was once its forty-three-mile path across central Long Island. Seeking out its remains inspired me to search for other forgotten places and moments—and find them I did.

v

Chapter 1

THE GLACIER STOPS HERE!

The first important event in Long Island's history happened around twenty thousand years ago, long before any humans set foot there. It was a time in geological history known as the Wisconsin Glaciation, the so-called Ice Age. Glaciers had advanced from the north, covering all of Canada and parts of at least twenty-four states with ice. Geographically, Long Island is a very special place, because it marks the southernmost point of glacial advancement. As the glaciers advanced, they accumulated boulders, rocks and earth and pushed this debris along. The point where they stopped advancing and began to melt is known as the terminal moraine, and Long Island has two of them, formed at different times: the younger Harbor Hill Moraine, skirting along the northern coast of Long Island; and the Ronkonkoma Moraine, running almost parallel but farther south.

The locations of these terminal moraines are marked by the island's lines of hills, including Suffolk County's highest point, the 401-foot-high Jayne's Hill (also known as High Hill, part of the Ronkonkoma Moraine) in Melville, and Nassau's highest point, Harbor Hill in Roslyn, at 348 feet (part of the Harbor Hill Moraine).

But creating Long Island's hills was not the only effect of the glaciers. As the ice melted, streams of runoff water flowed south toward the Atlantic, bringing tons of fine sediment with it and forming a flat outwash plain, comprising most of southern Long Island and accounting for the existence of the Hempstead Plains and the southern beaches.

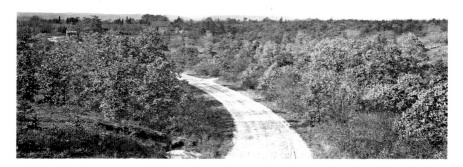

Looking north from south of Melville toward the Ronkonkoma Moraine and High Hill (aka Jayne's Hill), 1917. *United States Geological Survey.*

When chunks of the front of the glaciers broke off, they formed depressions, what are known as kettle holes. Many of these filled with water and became kettle lakes or ponds. Many such water bodies are scattered across Long Island, the largest being Lake Ronkonkoma, three-fourths of a mile in diameter, and the seventy-five-foot-deep Lake Success in the Nassau County village of the same name.

In this chapter and throughout the book, we'll find out how the Ice Age's impact on Long Island's geography affected its development and allowed for some fascinating moments in history.

SHELTER ROCK

During the last Ice Age, sometime between ten thousand and twenty thousand years ago, an advancing glacier—let's call it Derek—encountered a gigantic granite boulder in what is now Westchester County. Though the boulder was large, Derek was much larger, and as he moved, he carried the boulder along with him several miles to the southeast, depositing it in what would become the town of North Hills, on Nassau County's North Shore. Now, glaciers moving boulders was a frequent Ice Age occurrence, but this boulder is quite special. Known as Shelter Rock and marked by a

sign, it is the largest boulder on Long Island and possibly the largest in New York State. At five million pounds (eighteen hundred tons), the so-called glacial erratic measures fifty-five feet high by forty feet wide by sixteen feet deep and is located a mere forty feet off the southbound side of Shelter Rock Road, just south of Northern Boulevard (Route 25A). The "new" arrival was likely already five hundred million years old when Derek the Glacier brought this large metamorphic present to Long Island.

Despite its importance, not many people are aware of its existence. First, the sheer size of this boulder is hidden from sight because it lies in a valley twenty feet below the road. Second, it is on private property behind a fence, hidden by shrubs and trees.

The rock, also known as Milestone Rock and Manhasset Rock, got the name Shelter Rock due to its generous thirty-foot by twelve-foot overhang, which offers space enough for several people to receive shelter from wind and rain. But was there any proof that it was used for that purpose? An archaeological excavation for the American Museum of Natural History in 1946 found evidence of Native American presence dating to 1000 BC, making it one of the oldest human habitation sites ever found on Long

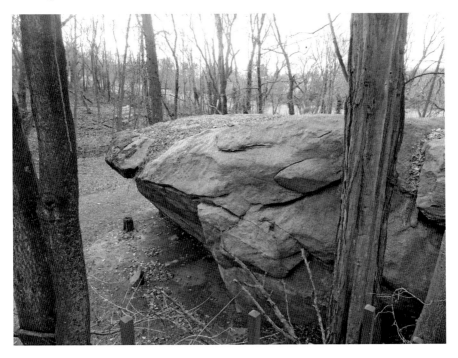

Shelter Rock. *Author's collection.*

Island. The site yielded twenty-seven projectile points, pieces of stone knife blades, pottery sherds, shell and animal bone fragments and several hammer stones used by the Matinecocks, who belonged to the Algonquin tribe.

There are a few legends associated with Shelter Rock. One of them tells of a young soldier running off with an Indian maiden, but he was shot with arrows before he could reach the overhang. Shelter Rock was also rumored to be the site of Captain Kidd's buried treasure. According to lore, the pirate lifted the giant boulder and dug a hole under the rock, depositing some of his booty there.

Shelter Rock was located on farmland until 1899, when the wealthy businessman Oliver Hazard Payne bought the land upon which it sits and left it to his nephew Payne Whitney, who died in 1927. Payne Whitney's son John Hay Whitney inherited the estate. J.H. Whitney, a major supporter of Dwight Eisenhower, was appointed U.S. ambassador to the United Kingdom. He also served as president of the Museum of Modern Art. Upon his death in 1982, the estate went to his widow, Betsey Cushing Roosevelt Whitney. In 1998, after the death of Mrs. Whitney, there was concern about the future of the property. What would happen to Shelter Rock if the property was sold? In the end, the property went to the Whitney family's Greentree Foundation, which had been founded in 1982. Greentree is a nonprofit, and the estate is now a conference center. The giant rock is safe for now, a hidden treasure that is barely visible by the thousands of drivers who pass by every day.

OTHER FAMOUS BOULDERS

Other glacial boulders made history on Long Island, too.

Council Rock, located on Lake Avenue just west of Oyster Bay Village, had its claim to fame in 1672, when the father of the Quaker movement, George Fox, arrived by ship at Oyster Bay and preached at a large boulder in the woods. The site was chosen because there was no building large enough to accommodate the crowd. (Later that year, one of the townsmen offered part of his land for the construction of a meetinghouse.) The boulder, located south of West Main Street, is noted by a historical marker. A second famous boulder also known as Council Rock sits just outside the Fort Hill Cemetery in Montauk, formerly the site where the Montauk Indians held tribal meetings.

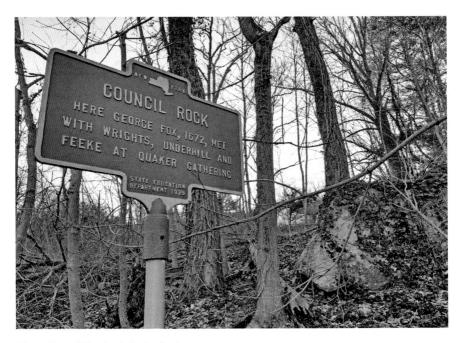

Above: Council Rock. *Author's collection.*

Below: The Nathan Hale Rock in Huntington. *Author's collection.*

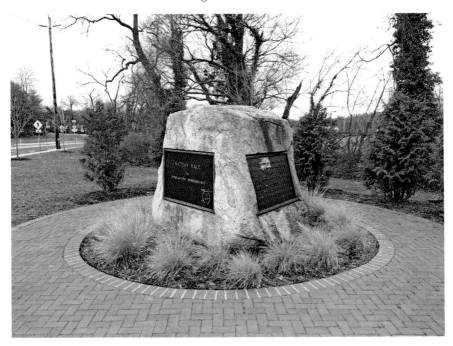

Another famous Long Island boulder sits at a traffic circle near the intersection of Mill Dam Road and New York Avenue in Huntington. The monument to Revolutionary War hero Nathan Hale was the creation of George Taylor, a resident who owned the land where the Patriot spy landed in 1776 after crossing the Long Island Sound from his native Connecticut and was captured by the British. Hale was taken to New York City and hanged there. Fascinated with Hale's story, Taylor had a boulder moved from near his house to closer to the beach to serve as a remembrance of Hale's landing spot. Affixed with commemorative plaques, the boulder remained in the Taylor family until the 1970s, when a descendant gave it to the Town of Huntington, which had the forty-five-ton boulder moved to its current location. Almost. Hale's boulder had to move again in 2012 when the roadway was reconstructed, to a spot about fifty feet from where it had been. The irony of this story is that, just like Hale, the boulder originated in Connecticut, though it was carried to Long Island by a slightly larger vehicle than Hale's boat—a glacier.

THE REMAINS OF THE HEMPSTEAD PLAINS

When you think of prairie, images of a certain little house in Kansas come to mind. The Great Plains are thousands of miles from Long Island, right? The answer is a resounding: No!

In fact, the only true prairie east of the Appalachian Mountains was located on Long Island. Though it is hard to imagine now, just a few hundred years ago, a sixty-thousand-acre grassland covered central Nassau County, extending from New Hyde Park all the way to Hicksville. It was formed by glacial outwash more than ten thousand years ago during the last Ice Age.

This flat land had a variety of uses over the last four hundred years. With its rich soil, the land was a good place to graze cattle and sheep and grow various grains. It also had a variety of sporting uses.

Horse races were quite popular in colonial days (see chapter 5). Hunting was another popular plains sport. There were a tremendous number of bird species that lived on or migrated to the plains. Daniel Tredwell, who kept a journal of his nineteenth-century Long Island adventures, wrote of a Hempstead Plains hunt that took place one day in 1843. His party shot eighty-two birds that Saturday and then went to the Hewlett Hotel, where they cooked up a bunch of the birds for dinner.

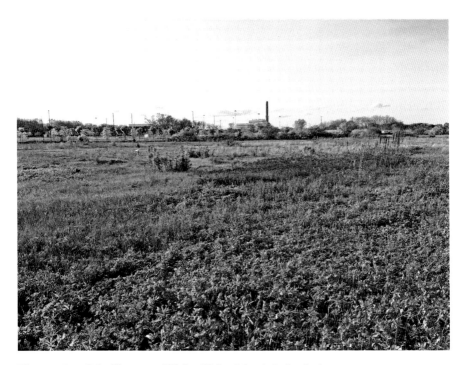

The remains of the Hempstead Plains, Uniondale. *Author's collection.*

With settlement, the plains began to shrink and change. An 1824 book said that "cultivation is gradually encroaching upon it, around the borders." One of the biggest factors in the disappearance of the Hempstead Plains was a man named Alexander T. Stewart. In 1869, Stewart bought seven thousand acres from the Town of Hempstead for $395,000 to create Garden City. Over the next several years, work was begun on transforming this grassland into a town. Stewart died in 1876, before his vision was fully implemented, but his widow, Cornelia, carried his plans through.

By the beginning of the twentieth century, there was still a considerable swath of plains left intact, just in time for a new use that would thrust this wilderness into the modern world: the airplane.

The flat stretch of land extending several miles was an ideal place for early aviators to set up airfields and experiment with the new technology that had been proven by the Wright brothers in North Carolina just a few years earlier. By 1909, aviation pioneer Glenn Curtiss was flying from Mineola, and within a few years, the area had cemented its status as the "Cradle of Aviation" (see chapter 4). By the 1920s, there were several airfields extending from Westbury west and south through what is now Mineola, Garden City

and Uniondale. The series of fields was perfect as a "hopping ground," allowing planes to take off and land (or crash-land, as it were) in a relatively safe way, far from populated areas.

As the airfields became more sophisticated, more of the plains were reclaimed by runways and pavement, though there were areas surrounding the runways that were still undeveloped grasslands. A 1937 article explained: "The plain is still there but it has lost a great deal of its significance since the countryside has been cut up with roads and cross roads and thousands of small houses dot the landscape."

Things changed again with the closing of the airfields in the 1940s and 1950s. The land was developed; Roosevelt Field Mall, the Source Mall, Hofstra University, Nassau Coliseum and the Marriott now occupy what had fairly recently been airfields and grasslands.

By 1970, the extent of the Hempstead Plains was less than one thousand acres. Nassau County preserved about sixty-two acres as a park that year, but the land was not maintained as a true prairie. What is left of the plains are two small areas. One is a strip of land adjacent to the Nassau Community College campus that is maintained by the Friends of the Hempstead Plains. Keeping the plains intact requires tremendous effort. Invasive, nonnative plant species would run rampant and take over the area without constant weeding and tending. There are 250 different types of plants that still exist on the plains.

The other remaining piece is a small strip that runs along the northern edge of Eisenhower Park. Interestingly, the only reason that bit of plains still exists is that it was part of the "rough" of the famous Red Golf Course in the park. The Red Course was designed in 1914 as one of five courses in the Salisbury Country Club. When the club went bust in the 1930s, the county took over the land and created what is now Eisenhower Park (then known as Salisbury Park). Four of the courses were scrapped, but the northernmost, Red Course, was retained, along with its accompanying strip of prairie.

TWO LAKES, TWO LEGENDS

Lake Success and Lake Ronkonkoma, both created during the Ice Age, have been the subject of fascination and legend for countless years. Both lakes are fairly deep and were thought to be bottomless until the nineteenth century, when they were finally measured.

Lake Ronkonkoma

It was alleged that objects dropped into Lake Ronkonkoma made their way through subterranean chambers into the Great South Bay and the Atlantic Ocean. This notion has since been proven false. Eighteenth- and nineteenth-century settlers also heard stories about a ghostly Indian girl ("The Lady of the Lake") who haunted the lake and took a male victim once a year. According to the tales, the Lady would call her victims and lure them into the deeper waters, and then the unlucky boys would be found drowned some time later.

Lake Success

A bizarre legend about Lake Success originated about two hundred years ago, when a boy named Harry went fishing at the deepest part of Lake Success and reeled in not a fish but a woman, with the hook in her lip. The beautiful young woman said to the stunned boy: "Harry, Harry, cut the line, and permit me to descend, for I am not mortal but a Naiad, who reside in the deepest recesses of the pond." Harry had other ideas, however, and thought he could put her on display, charge admission and make a fortune. When she saw he was not going to let her go, she pulled the line out herself and said angrily: "You fool, since you will not benefit those whom Providence places within your influence, no man shall be able to benefit you." Undaunted, the boy shook off this prediction and went home and proceeded to tell everyone of his adventure.

One of his friends decided to go to the pond to try to catch this creature for himself. Before long, he'd caught the woman, who was very distressed and pleaded with him, "Richard, cut the line and permit me to descend." Well, whatever the boy's intentions had been before, he was so moved by the sea creature's plea that he took out his pocketknife to cut the line, but she then removed it herself and said to him, "Dear youth, since you are unwilling to injure the unfortunate, no man shall be able to injure you!" Harry grew up to be selfish and self-righteous, letting others study for him and then not getting into college, failing at business and failing at farming and losing his wealthy father's favor. Though of poor parentage, Richard was a success, cautious and considerate, surviving others' attempts at maligning him through honesty and modesty, and he wound up becoming a successful lawyer. One day, fifteen years after the encounter at Lake Success,

he decided to venture back there and try once more to catch the Naiad, but all he caught was an old fish net. Inside the net was a stone tablet with the words, "The man who will not injure himself, no person can injure." As of 1858, this stone tablet was said to be preserved under a glass case and displayed on a mantel by the innkeeper at Lake Success.

Chapter 2

LONG ISLAND AT WAR

For centuries, Long Island has played a critical role in the nation's military conflicts, providing training grounds for tens of thousands of troops and serving as a manufacturing center for World War II's most powerful fighter planes. In this chapter, we'll take a look at some of the many contributions made by Long Island and its inhabitants.

The story begins with the Revolutionary War, which had a huge impact on the island. When New York was in danger of capture by the British in 1776, hundreds of Patriots fled across Long Island Sound to Connecticut. Those who remained, whether "rebels" or Loyalists, were desperate to protect their crops and their animals. As the summer of 1776 arrived, preparations were made to protect valuable resources.

LONG ISLAND'S REVOLUTIONARY MARTYR

In late August 1776, the British were nearing New York, and American general Nathaniel Woodhull was ordered to go from his home in Mastic in Suffolk County to Jamaica, where he was to take charge of a company of militiamen and drive cattle (as well as transport grain and provisions) from western Long Island to the east to keep this valuable livestock out of British hands. In the days that followed, Woodhull succeeded at least in sending fourteen hundred head of cattle to the Hempstead Plains. It was not easy

During the Revolutionary War, British soldiers are said to have used the weathervane atop St. George's Church in Hempstead for target practice. The church was since rebuilt, but the weathervane is the original. *Author's collection.*

considering he was short of men, who were losing hope in the cause as the days passed. "The people are so alarmed in Suffolk," Woodhull wrote on August 28, "they will not any more of them march; and as to Cols. Smith and Remsen, they cannot join me, for the communication is cut off between us....My men and horses are worn out with fatigue."

On the very same day Woodhull wrote his letter, General George Washington's troops engaged General William Howe's troops in Brooklyn in what was known as the Battle of Long Island. The British overwhelmed the Americans, but luckily Washington was able to evacuate most of his troops across the East River to Manhattan. Woodhull had requested reinforcements, but Washington's reply was that the men were needed to protect New York City. A couple of days later, Washington decided to give up Long Island to the British, due to the "fear of having our communication cut off from the main…and the extreme fatigue our troops were laid under in guarding such extensive lines without proper shelter from the weather."

Woodhull ordered his men to fall back to a position four miles east of Jamaica while he remained in Jamaica village to gather intelligence about

the just-ended Battle of Long Island. Proceeding east along the turnpike, he intended to join his men, but a severe thunderstorm caused him to take shelter at Carpenter's Tavern at what is now Jamaica Avenue and 197th Street in Hollis, Queens. Not long after he had hitched his horse to a post behind the tavern and taken a seat inside, the British Light Dragoons arrived. Woodhull ran toward the back door and struggled to unlatch it. He finally went outside and ran toward his horse, but it was too late. He was surrounded. He was forced to surrender and give up his sword. Next comes the part that sealed Woodhull's place in American legend. Now officially a prisoner of the British, Woodhull was supposedly asked to say, "God save the King." Instead, he said calmly, "God save us all," which inspired the wrath of one of the British officers, who struck Woodhull repeatedly on his head and arms with a sword. Woodhull fell to the ground and was carried to a maple tree near the tavern, where he rested until being taken to Jamaica, and from there to Brooklyn. His arm was amputated, and he died from his injuries on September 20.

This eighteenth-century home in Huntington came to be known as the "Arsenal" after its occupant, a weaver, hid stores of gunpowder in the attic as British occupation during the Revolutionary War was imminent. *Author's collection.*

The tavern was later known as Goetze's Hotel. As late as 1917, the heavy door and latch that slowed Woodhull's escape were still visible. In 1912, the Sons of the Revolution erected a bronze tablet at the site. The march of progress had no place for the old tavern, and it was demolished in 1921 and housing erected in its place. A cannon and memorial granite block on the grounds of PS 35 (90th Avenue and 191st Street in Hollis), as well as Woodhull Avenue (which runs southwest from Jamaica Avenue at 197th Street and then loops back north to meet Jamaica Avenue again at 188th Street), are the remaining vestiges of this historic spot and this martyred homegrown Long Island hero. He is buried in the family burial ground on Cranberry Drive in Mastic Beach.

ISLAND OF CAMPS

The Hempstead Plains was an ideal location for military encampments. Not far from New York City, the flat, uninhabited expanse of fields was perfect for training and housing troops. During the Revolution, the British army's Seventeenth Light Dragoons were stationed there, and soldiers were again trained on the plains during the War of 1812, the Mexican War (1846) and the Civil War (this camp, located at about Eleventh Street and Washington Avenue in Garden City, was known as Camp Winfield Scott).

Listed below are some of the camps.

Camp Black

This camp was established two miles east of Garden City in the spring of 1898 to train men heading to battle during the Spanish-American War. The camp (a historical marker for which is located on Stewart Avenue about one thousand feet east of Clinton Road) sprung up with lightning speed. The idea for a camp on the Hempstead Plains was first proposed on April 22, 1898, and the soldiers arrived just ten days later. As the area was undeveloped, the government had to pay $6,500 to have the Hempstead Water Company lay five miles of pipe in order to supply the troops with drinking water. Work began on April 30 and was completed in six days. By May 2, eight thousand men had arrived at Camp Black

(named in honor of Governor Frank Black), were sheltered in tents and had straw to sleep on and wood for cooking fires. Their baggage was moved from the train station to the camp by farm wagon. Nine thousand loaves of bread were delivered to the camp every morning. The camp was closed on September 28.

Camp Wikoff

As the Spanish-American War came to an end in July 1898, an outbreak of yellow fever raged through the American army's camp near Santiago, Cuba. The U.S. government knew that the priority was to get the troops away from there as quickly as possible and to create a camp for the returning soldiers. Montauk Point was selected as the perfect spot for a camp to hold these men, serving the dual purpose of treating anyone who was sick or injured and quarantining them from the general population to prevent a larger outbreak of yellow fever. Camp Wikoff was to be created

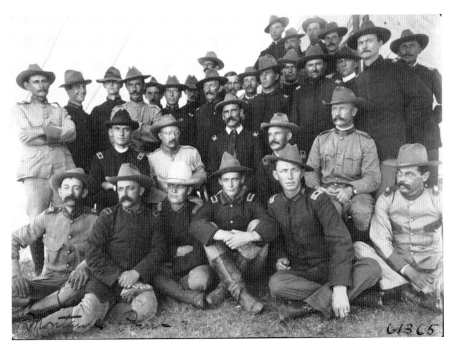

Officers of the Rough Riders at Camp Wikoff, 1898. *Library of Congress.*

on several thousand acres of land as quickly as possible. Thousands of tents were ordered, and two million feet of lumber were brought in to construct storage buildings and tent floors. About one hundred nurses were brought in, along with doctors, cooks and other support staff. The first troops arrived before the tents did and had to sleep under blankets in the open air. As quickly as it was constructed, the camp was not prepared when the first troops arrived on August 8.

This inauspicious start was only the beginning of the camp's troubles. Various complaints about the health conditions at the camp led to several investigations by government agencies and the press. One investigation found that, due to a water shortage, over 1,000 men were forced to drink from a local pond, which was causing them intestinal ailments. The hospital was perpetually overcrowded (some patients had to lie on the floor for lack of cots) and ill equipped to handle the large and rapid influx of ailing soldiers. Hundreds of sick soldiers had to be sent to New York City for further treatment. Many were dying in the camp. The secretary of war and President William McKinley both visited the camp to review its conditions, which finally improved by September. A total of 21,870 troops stayed at Camp Wikoff, with about half of those requiring some medical attention. The most famous of those troops were Colonel Theodore Roosevelt and his Rough Riders. The entire camp was abandoned by the middle of November 1898, less than three months after opening.

Camp Mills

With America's entry into World War I imminent in 1917, troops needed places to train, and Long Island was an ideal spot to get troops prepared for their journey across the ocean to France. Camp Mills was the largest training center for American Expeditionary Forces during World War I, with eighty thousand men training there. It served as the final stop before Europe for men arriving from camps around the country. Originally a tent city when it opened, in 1918 the camp became more permanent, with the construction of eight hundred buildings. The massive base hospital had twenty-five hundred beds. The boundaries of the camp, located in Eastern Garden City, were Clinton Road on the west, Meadow Street on the south, the LIRR Central Branch railroad tracks on the north and open plains (which would become Mitchel Field) on the east.

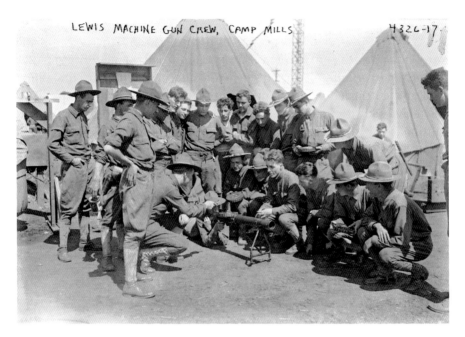

A Lewis machine gun crew at Camp Mills, 1917. *Library of Congress.*

Douglas MacArthur, F. Scott Fitzgerald, Harry S. Truman and Joyce Kilmer (who died in France in 1918) all spent time at Camp Mills. When a relieved Harry Truman returned from service in Europe to Camp Mills in April 1919, he sent a telegram to his wife telling her he had been "eating pie and ice cream" ever since he arrived. Fitzgerald would write about Camp Mills in his novel *The Beautiful and the Damned* (1922). Camp Mills was officially closed in 1919.

Camp Upton

Construction on this camp at Yaphank in Suffolk County began in the summer of 1917 and was completed by December, but recruits had already begun arriving in September. A total of forty thousand soldiers trained at Camp Upton, one of whom was an already famous Irving Berlin. He wrote a musical called *Yip, Yip Yaphank* while stationed there, later to become a Broadway show that opened in 1918. While the show itself has been forgotten, it contained one of Berlin's most popular tunes (and sentiments):

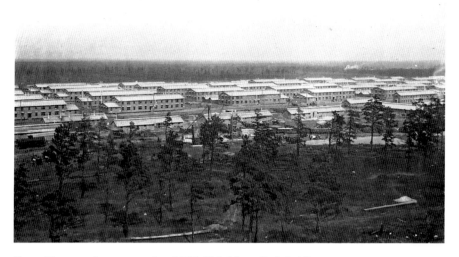

Camp Upton under construction, 1917. *United States Geological Survey.*

"Oh, How I Hate to Get Up in the Morning." The camp was deactivated after World War I but rebuilt during World War II. After the war, the camp became Brookhaven National Laboratory (opened in 1947), and many of its buildings were reused by the government.

Mitchel Field

Though Mitchel Field was opened as an army base in 1917, it was not until 1929 that an ambitious building program and expansion transformed the base into a major installation. Elegant brick buildings replaced wooden ones, and new construction included everything from private homes for families and a dormitory-style building for bachelors to a gym, theater, radio station and library. A parade ground provided a parklike atmosphere in the midst of the military buildings. The Cradle of Aviation Museum's history page for Mitchel Field says it was the army's "premier air corps base" because of its clublike atmosphere and aesthetically pleasing architecture, attractive landscaping and numerous amenities within a well-planned layout.

Mitchel Field closed in 1961, and though there is almost nothing left of the airfields (see chapter 4), the remnants of the base itself are numerous. Many of the 1930s buildings are still intact, just north of the Firefighters Museum, Nunley's Carousel and the Children's Museum of Long Island. The larger

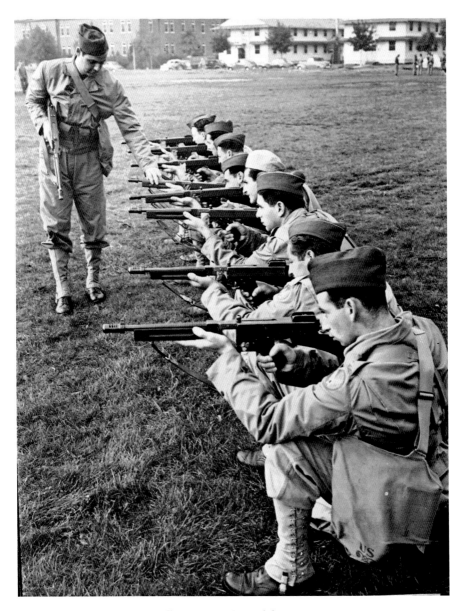

Training of soldiers at Mitchel Field, 1942. *Library of Congress.*

ones serve as classrooms or administrative buildings for Nassau Community College (NCC). For example, Building 105, formerly headquarters of the First Bomber Command, is now NCC's North Hall. Dozens of officers' quarters still grace the former base's stately tree-lined streets. Some still

29

house military personnel who are stationed in the area; others are owned and rented by a private company. The original commissary building still serves as a commissary for those military personnel who live at Mitchel Field.

While much of the former base looks quite civilized and friendly, the eastern end of the old base, along and near Railroad Avenue, is where some of the more desolate remnants of Mitchel Field can be found. The quaint but boarded-up and decaying Building 21 was the radio station. A row of three abandoned and windowless service buildings hugs the northwestern corner of the base. Inside the smallest and plainest of the trio, a time-stands-still kind of sight awaits—different-sized gaskets hang from hooks on the wall, waiting patiently for more than half a century to be placed on machinery long gone. A row of military warehouses still stands, now repurposed for commercial use. Two sets of abandoned rail tracks that spurred off the LIRR's Central Branch line still come down the center of the ramshackle road (which leads to a vast parking lot on whose western border lies a gutted trailer of unknown origin or purpose), once bearing freight loads of goods to be stored in the warehouses, which are similar in their shape and architecture to the base's hangars.

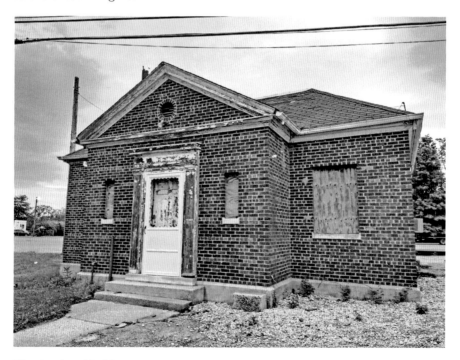

The abandoned Building 21 at Mitchel Field, formerly the base radio station. *Author's collection.*

FLIGHT AND FIGHT

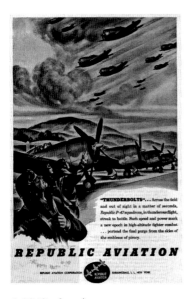

A 1943 advertisement for Republic Aviation in Farmingdale. *Author's collection.*

Long Island was not only the site of groundbreaking flights, it was also home to two of the country's biggest and most important aircraft manufacturers: Republic and Grumman. Founded in 1931 as Seversky Aircraft, Republic Aviation was based in Farmingdale and was responsible for building the P-47 Thunderbolt fighter plane during World War II. More than fifteen thousand of these planes were constructed on Long Island and in Evansville, Indiana, by 1945. The company was acquired by Fairchild in 1965.

Grumman Industries (later Grumman Aerospace and now known as Northrup-Grumman) was founded in 1930 and moved to Bethpage in 1936. The company bought a large plot of land bordering South Oyster Bay Road on the west, from the LIRR tracks south to the intersection with Route 107. At the time, Bethpage was a semi-rural community of farms. It was the perfect place for a large operation to manufacture fighter planes for the U.S. government. As the years passed and the country ramped up its defense with the start of the war in Europe, the Grumman complex grew to include several factory buildings, testing facilities, hangars and runways and taxiways. During World War II, there were about twenty-five thousand employees at the Bethpage complex. Grumman's most famous aircraft of that era was the navy's carrier-based F6F Hellcat. More than twelve thousand of these powerful planes were produced in just two years. Grumman continued to be strong through the Cold War and was heavily involved in the space program since 1962, building thirteen lunar modules (one of which is on display at the Cradle of Aviation Museum a few miles to the west). The workforce was still a healthy twenty-five thousand in 1986, but cuts forced it down to three thousand by 1996, when Grumman announced a huge scale-back and sell-off.

Grumman was such a huge part of Long Island's incredible aviation history that I needed to see the site for myself. I was only sorry that I waited

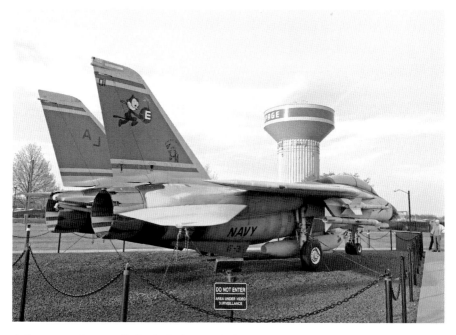

A Grumman plane on display in Bethpage. *Author's collection.*

until 2016. As late as 2005, there was much of the original runway and many of the old buildings still intact. So much has changed so drastically in such a short time. Now, aside from some original Grumman parking lot blacktop and a couple of the original old buildings, I'd apparently missed the last remnants of this once sprawling complex. After Grumman sold off land, things changed quickly, and the property was repurposed. A drive on Grumman Road West (which didn't exist back in the day) is a trip through history—the last ten years of history. It's all new. And it feels very new. Shiny new buildings, new parking lots, deep green new grass and a water tower are now present where the main Grumman runway once was.

The most obvious sign of the area's past is the fierce-looking F-14 Tomcat fighter plane that sits near the intersection of Grumman Road West and South Oyster Bay Road. I'd read about it and wanted to check it out. Parking nearby, I saw that there were people there. "Oh great," I thought. "I want to take photos of the plane, and these folks are going to be in my way. I'll have to wait until they leave to get a good shot."

The group looked to be a grandfather, son and grandson, and they were taking photos and walking around the plane. "This is going to take a while,"

I thought. At 6:30 p.m. on a weekday, who would think anyone would be here! I read the plaque in front of the plane to get some more background. The F-14 was first flown in 1970 and last flown in 2006. Production on the plane ceased in 1992. The plane on display was number 711 of the 712 made, and it was the last one to be flown.

After reading the plaque, I then walked around, trying to get a good shot without the other visitors in it. I got a couple of photos, and then I went around to the other side. The old guy was now standing a few feet from me as I looked at the plane. He seemed to be lost in thought, admiring the plane. Suddenly, he spoke to me. "I designed the tail feathers on this plane."

I was astonished. What were the odds? "You did?" I asked.

"Yup, fifty years ago."

And then the requisite dumb question: "So, you worked for Grumman?"

He nodded, "I sure did, right here." And then he proceeded to tell me more, adding a story about a design issue with the engine and how it was resolved. Turns out, the boy was doing a report for school on the plane and was going to interview his grandfather right after. As they were on the far side of the plane and about to leave, I snapped more photos. They left, and I remained for a few minutes absorbing the coincidence and good fortune.

On my way out, I passed one of the remaining old Grumman buildings, which has a new life as a film studio, Grumman Studios. (It bills itself as the largest film production facility on the East Coast.) Opened in 2009, the 460,000-square-foot space got off to a quick start. Among the films shot at Grumman Studios were *The Amazing Spider-Man 2, Annie, The Avengers, Peter Pan Live!* and *The Sound of Music Live!*

COLD WAR MISSILES

The Cold War began the moment World War II ended and had the entire nation on edge for years. The Soviets might try anything, at any time! With the rise of the Iron Curtain in Europe and signs of growing Soviet ambition for world domination, there was widespread fear. What if Soviet bombers appeared over our skies? How could we stop them? The Nike missile program was created in 1945 with the purpose of developing a missile that could target a fast-moving, high-altitude plane. The Nike missile (later known as the Ajax missile when a newer version called the Hercules missile was introduced) was the first surface-to-air missile. It was thirty-two feet long and weighed thirty-

two thousand pounds. It had a range of thirty miles, a ceiling of seventy thousand feet and a maximum speed of Mach 2.25.

Now that missiles were in production, the government had to figure out where to place them. Dozens of strategic sites around the country were selected, including nineteen missile batteries in the New York metro area. Between 1955 and 1957, the federal government built five Nike missile sites on Long Island: at Lloyd Harbor, Lido Beach, Rocky Point, North Amityville and Brookville. The missiles were stored underground. The largest installation, Lido Beach, could hold sixty missiles, each with three warheads. Each Nike battery comprised more than 1,500,000 parts, including 12,000 resistors, 2,000 vacuum tubes, 460 relays and 1,250 coils. The sites were manned by army units consisting of 6 officers and 102 enlisted men each. The sites were later taken over by the U.S. National Guard. The Rocky Point and North Amityville sites were later converted to accommodate Hercules missiles, which were faster and more powerful than their predecessors, the Ajax missile.

These bases may be hidden history now, but they were not secrets at the time. The general public could visit the missile sites every second Sunday of the month. According to a 1958 edition of the *Long Island Star-Journal*, "The officers and men hope their neighbors on Long Island will drop by to say 'hello'…and look around."

As technology and the times changed, the Nike missile sites became obsolete. The first of these Long Island sites to be abandoned was Lloyd Harbor in 1962. Brookville and Lido Beach followed in 1963, Rocky Point in 1971 and North Amityville in 1974. Visible remains of these sites range from a fence at Lloyd Harbor to buildings and remnants of installation infrastructure at the other sites. Brookville's site underwent a very interesting rebirth. After its missiles were removed in 1974, the site was donated to the Town of Oyster Bay and the Board of Cooperative Educational Services of Nassau County (Nassau BOCES), which set out in 1975 to create a circa 1800 living history environmental homestead. Student volunteers helped build a log cabin by hand and dismantle the old barracks buildings, reusing the floor boards, beams, roof and nails to make walls for a blacksmith shop. Near the parking lot, just beyond the hand-hewn glory of the re-created rustic past, lies a large concrete platform with several embedded steel panels—the remains of what was once a missile launching pad.

PIRATES, PRESIDENTS, POETS AND PREACHERS

L ong Island has been host to countless fascinating personalities over the past four hundred years. Some were just visiting, some moved to Long Island from elsewhere and some were born and raised on the island. All of them have played a part in the island's history, becoming part of the lore and legend. In this chapter, we'll encounter a few of these celebrities—from the ubiquitous to the nearly forgotten—and take a closer look at their Long Island stories.

CAPTAIN KIDD'S LONG ISLAND ADVENTURES

In the seventeenth century, piracy on the high seas was such a serious problem that the British government turned to a respectable New York City citizen, Captain William Kidd (1645–1701), and asked him to go out to sea and hunt pirates. Kidd was given an armed ship and rounded up a crew. Though he left New York in 1696, Kidd made no captures for more than a year. It seems that the supposed pirate-chaser had gone rogue and become a pirate himself. In 1698, he captured an Armenian vessel called the *Quedagh Merchant,* yielding £64,000 of treasure. Kidd insisted he was a privateer, not a pirate, but also that his men had revolted and forced him to cross the line at times.

Kidd returned to North America in June 1699. He left the stolen ship and part of his crew in the Carribean for safekeeping and found himself a

smaller ship, then sailed with forty men toward New York. He was hoping for protection from Richard Coote, aka the First Earl of Bellomont, who was the royal governor of New York and New England. Instead of a welcome, Bellomont sent an armed sloop after Kidd. The pirate had pulled into Delaware Bay to repair his vessel and then left quickly, sailing away in time to avoid crossing paths with the sloop. When he neared New York, he veered to the east and sailed along the southern coast of Long Island, around the eastern tip and into Long Island Sound. He kept going until he reached Oyster Bay, where he stopped and anchored his ship. He wrote a letter to Bellomont and another to his wife and children and sent them off with a messenger to New York City.

He wrote to the earl from his ship in Oyster Bay: "The reason why I have not gone directly to New York, is that the clamorous and false stories that have been repeated of me, have made me fearful of visiting or coming into any harbor, till I could hear from your lordship."

A day or two later, in response, a lawyer and friend of Kidd's named Emott came from New York and visited Kidd on board the *Antonio* at Oyster Bay. He told Kidd that the Earl of Bellomont was in Boston. Kidd asked Emott to go to Boston and obtain a promise of safety if Kidd should visit him there.

Kidd told the lawyer to tell Bellomont the following:

> *Unquestionable piracies have been committed by men nominally under my command. But this has never been by my connivance or consent. When these deeds have been performed, the men have been in a state of mutiny, utterly beyond my control. Disregarding my imperative commands, they locked me up in the cabin, and committed crimes over which I had no control, and for which I am in no sense responsible.*

He took Emott to Rhode Island, dropped him off there and dispatched him to Boston to deliver his message to Lord Bellomont, whose reply was encouraging:

> *Mr. Emmot [sic]...told me you came by Oyster Bay in Nassau Island and sent for him to New York. He proposed to me that I would grant you a pardon. I answered that I had never granted one yet, and that I had set myself a rule never to grant a pardon to anybody without the King's express leave or command. He told me you declared and protested your innocence....That you owned there were two ships taken, but that your*

Captain Kidd's ship was anchored at Oyster Bay in 1699. *Author's collection.*

men did it violently and against your will, and had used you barbarously, in imprisoning you and treating you ill the most part of your voyage, and often attempting to murder you....And this I have to say in your defence, that several persons in New York...did tell me that...they were informed of your men's revolting from you in one place...and that others compelled you much against your will to take and rifle two ships.

I have advised with His Majesty's Council, and shewed them this letter, and they are of opinion that if you can be so clear as you...have said, that you may safely come hither...and I make no manner of doubt but to obtain the King's pardon for you....I assure you on my Word and Honour I will perform nicely what I have promised, though this I declare beforehand that whatever goods and treasure you may bring hither, I will not meddle with the least bit of them: but they shall be left with such persons as the Council shall advise until I receive orders from England how they shall be disposed of.

Kidd must have taken some comfort in this reply and yet had an uneasy feeling about the course of events to come, because he felt an urgent need

to hide his treasure. He anchored his ship off Gardiner's Island (about five miles northwest of Montauk) and met with John Gardiner, owner of the island, on board the ship. Kidd decided to bury his treasure on the island for safekeeping. He had it buried under an old oak tree and swore Gardiner to secrecy, telling him that if the treasure wasn't there when he came back, he would kill Gardiner. All Gardiner received as thanks was some sugar, which, though scarce, was hardly a treasure. Some members of Captain Kidd's crew also entrusted their possessions to Gardiner, who received some stockings for his trouble.

Kidd sailed for Boston and arrived on July 1. Bellomont's promise did not carry much weight, because by July 6, Kidd had been captured and thrown in jail. The authorities wanted to know where the treasure was. Kidd eventually relented and told them that John Gardiner would be able to tell them where on his island the treasure was buried. Since Gardiner wanted to cooperate and avoid being connected to Kidd, rather than go empty handed, he went to the secret spot, dug up the treasure and brought most of it with him to Boston (leaving behind some quilts and fabrics). The treasure included 1,111 ounces of gold, 2,353 ounces of silver, 17¾ ounces of rubies, exotic fabrics and a bushel of nutmeg and cloves. Seized from Kidd's ship were fifty-seven bags of sugar.

When Gardiner returned from Boston, legend has it that, as he unpacked his bag, a diamond dropped out. He wanted to send it to Boston, but his wife told him to keep it after all the trouble Captain Kidd had caused him. Kidd was deported to England, where he was eventually tried, found guilty (not of piracy but of murder) and hanged in 1701. Part of his Gardiner's Island treasure was sold at auction in London in 1700 and brought a price of about £6,500.

Though Oyster Bay and Gardiner's Island are the only two confirmed Long Island locations visited by Captain Kidd, rumors have abounded for centuries of buried treasure at other locales along the North Shore. According to one 1907 book, "He is said to have landed at dead of night at quiet and solitary places all along the Shores of Long Island…with sacks of gold and bags of jewels which he buried in the sands or under rocks." There was even a rocky ledge known as "Kidd's Ledge" where he was thought to have hidden treasure. Long Island treasure hunters have been searching for Kidd booty since the 1700s, excited by certain trees and rocks bearing mysterious marks that they took as clues to the loot's location, but thus far, nothing has been found.

THE LEGEND OF PIRATE JONES

Near Massapequa Lake (in an area that used to be known as Fort Neck), there stood for many years a venerable brick house known as the "Old Brick House." In 1692, a man named Major Thomas Jones came to America from Ireland and settled at Fort Neck on a vast plot of land. He built the brick house in about 1695 and lived there for nearly twenty years. Known as Pirate Jones, the "pirate" was in fact a privateer who had been authorized to seize enemy ships. But the line between pirate and privateer was a fuzzy one. In any event, Jones's pirating days were supposedly over once he moved to Long Island. In 1704 he was named the high sheriff of Queens County. In fact, Jones Beach, which sits on land originally owned by Major Jones, is named after him.

As the years passed, many legends have emerged about Jones. It was said that he buried some of his old pirate treasure nearby. As the story goes, one day he came upon a black boy and asked if he would guard the treasure. When the boy agreed, Jones supposedly killed the boy and threw his body upon the chest as he buried it in swampy ground. Local residents told of hearing the boy's cries in the swamp where the treasure was supposed to have been laid (which subsided once the swamp was flooded when a dam was built nearby). Major Jones eventually grew old and sick, and legend has it that as the aged Jones was taking his last few breaths in December 1713, a big black bird flew into his room and perched upon his pillow. The bird remained in the room until the old pirate passed away and then flew out of the house through an oval window.

Thomas Jones was buried among Native American ruins on his property. His gravestone featured words that he had dictated: "From distant lands to this wild waste he came, this spot he chose, and here he fixed his name; long may his sons this peaceful spot enjoy, and no ill fate their offspring ere annoy." Though his gravestone wished his descendants well, strange goings-on occurred after his passing. To start, after his death, the oval window could not be closed properly. Every night, the pirate's ghost would enter the window and take a walk. As legend of this haunted house spread, people came from all around to see the mysterious oval window. Jones's sons and grandsons tried desperately to close the troublesome window—they locked it, boarded it up and bricked it over every which way they could, but as soon as night came "their work would be destroyed, and strange sights would be seen and awful voices heard." They finally gave up and moved out of the house for good. One of Jones's sons built another house on a

different part of the property, but he would have nothing to do with the haunted brick house.

The old brick place was finally torn down in 1837, after more than one hundred years without occupants, and with it disappeared the pirate's ghost. The physical remains of Major Thomas Jones also had some adventures. Rumors had circulated that he had been buried with some valuables, and vandals dug up his grave, leaving the bones scattered. Someone took the upper half of Jones's skull, thinking it to be of some value. The missing bone was not reunited with the rest of the remains until 1893. The family discovered that someone had scrawled on the grave a little rhyme that went: "Beneath these stones repose the bones of Pirate Jones. This briny well contains the shell, the rest's in hell."

WASHINGTON WAS HERE

The first president to visit Long Island was...the first president. George Washington made a three-day tour of Long Island during the first full year of his presidency, in April 1790. It was one of just three presidential trips he took while in office—the other two being to New England and to the southern states.

At the time, the federal capital was located in New York City, so the visit was not terribly inconvenient. Washington's Long Island route took him from Jamaica on through Hempstead and went as far east as Brookhaven. On April 20, he crossed the river over to Brooklyn (having sent his servants, horses and carriage over earlier), from whence he journeyed to Jamaica. He left Jamaica on the "clear and pleasant" morning of April 21 and followed the road to "South Hempstead," which is actually Hempstead. There he stopped at the "House of one Simmonds, formerly a Tavern, now of private entertainment for money." This tavern is generally believed to have been located at the corner of Fulton and Main Streets and was actually called Simmonson's.

From there, the president's entourage headed south for five miles to what is now the Merrick/Freeport area, in view of the ocean, and then headed east, passing "small bays, marshes and guts" along the way. He stopped at Ketchum's in Amityville to dine and then continued along the road to the house of Judge Isaac Thompson at Sagtikos Manor, where he spent the night. The house, built in 1697 and still standing, is today a museum.

The next morning, April 22, Washington continued east for about eleven miles, to the Greene farmhouse in Sayville. He stopped for a rest and then continued on to Hart's Tavern in Brookhaven, on the north side of the Montauk Highway (Route 80). He then went north through Coram and on to Setauket, where he stopped at the inn of Captain Austin Roe (at Main Street and Bayview Avenue), which he said was "tolerably decent" with "obliging people in it." The next morning, Washington left Roe's and headed west back toward New York. He stopped at Smithtown to feed and water the horses at the Widow Blydenburgh's. He proceeded to Huntington, where he stopped at the Widow Platt's, a building that stood until 1860. The site is now marked with a sign.

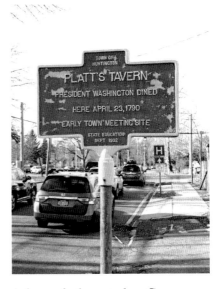

A sign marks the spot where George Washington dined in Huntington in 1790 on his tour of Long Island. The building was demolished in the nineteenth century. *Author's collection.*

One quick stop that is not mentioned in Washington's diary was in Cold Spring Harbor, just west of Huntington, where Washington encountered a group of citizens working on building the village's first schoolhouse. Much to the delight of the residents, the president stopped to greet them, and this spot, just behind the Fish Hatchery, is marked with a commemorative sign.

He went onward to Oyster Bay, where he stopped at Youngs' place, a small house that still stands today on East Main Street just past the intersection with South Street, across from the First Presbyterian Church.

After spending the night there, he continued west to Roslyn, where he had breakfast at Henry Onderdonk's house (which was to become the popular restaurant George Washington Manor) at the corner of Main Street and Old Northern Boulevard; it is now known as Hendrick's Tavern. While in Roslyn, Washington toured one of Onderdonk's two paper mills and, as legend has it, made a sheet of paper. In his diary, Washington mentions a third Onderdonk mill, a seventeenth-century gristmill that still stands on Old Northern Boulevard. The original 1773 paper mill that Washington visited (the first paper mill on Long Island) was replaced in 1915 with a replica that now sits in Gerry Park.

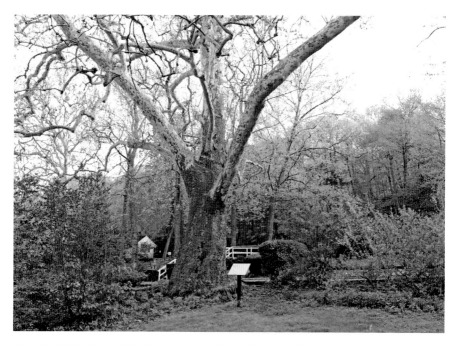

Above: In 1790, George Washington greeted local citizens building Cold Spring Harbor's first schoolhouse on this spot. *Author's collection.*

Below: George Washington spent a night in Roslyn at the Onderdonk residence, later a restaurant known as George Washington Manor and more recently known as Hendrick's Tavern. *Author's collection.*

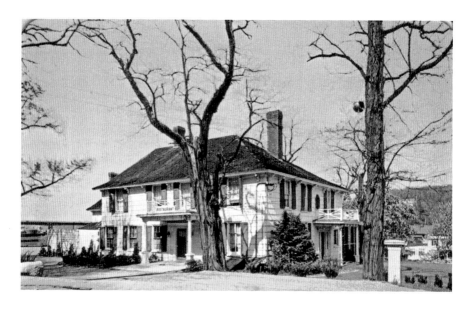

Thus ended Washington's tour of Long Island. From Roslyn, he headed back to Flushing and then Newtown, where he got a ferry back to Manhattan. There are twelve distinct sites on Long Island associated with George Washington. Interestingly, aside from commenting on the reception, food and lodgings at his various stops, his diary makes no note of any crowds of people greeting him along the way. Instead, he mainly devoted space to describing the soil and terrain on his voyage. Though he was well liked, the reverence for Washington that we know today came after his death, a product of the nineteenth-century culture of "Washington Slept Here."

Teddy Roosevelt and the Octagon Hotel

Long Island is full of associations with Theodore Roosevelt. In fact, when I first moved into my house, the woman who lived across the street from me, born in 1899, told me she grew up in Oyster Bay and could remember hearing Teddy Roosevelt give a speech when she was a child.

Roosevelt attended countless ceremonies, gave dozens of speeches and laid many a cornerstone on Long Island from the time he became governor of New York all the way until his death in 1919. Even while he was president, he spent a lot of time at Sagamore Hill, which he used as his Summer White House. One of his most prominent appearances was in 1900, when he laid the cornerstone of the old Nassau County Courthouse on Franklin Avenue in Mineola, now called the Theodore Roosevelt Legislative Building.

Some of the sites with TR associations have interesting back stories, and the Octagon Hotel in Oyster Bay is one of them. Located on West Main Street, the Octagon Hotel was built in 1851, part of a brief craze that resulted from the belief that octagonal buildings were good for the health. The craze stemmed from a 1848 book called *Octagon House: A Home for All* by Orson Squire Fowler. It touted the increased light and ventilation of this building shape. The building is one of seven octagonal structures left on Long Island. What distinguishes it from the others is its association with Teddy Roosevelt. In 1899, when Roosevelt was governor of New York, his secretary had an office on the second floor of this building. Roosevelt visited the hotel many times, for political and social functions and meetings, and visitors to see him stayed there. Even when he was still governor-elect in December 1898, the flow of visitors had begun. On December 13 alone, seven political visitors called on TR at

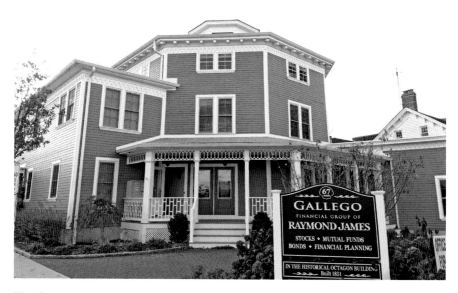

The Octagon Hotel in Oyster Bay has several associations with Theodore Roosevelt. *Author's collection.*

Sagamore Hill, including a delegation of four influential men from Long Island City who were staying at the Octagon Hotel.

Roosevelt's association with the Octagon Hotel continued after he became president in 1901. In 1902, Secret Service agent William Craig, a frequent visitor to the hotel, was killed in Pittsfield, Massachusetts, when a trolley rammed into President Roosevelt's carriage, becoming the first Secret Service agent killed in the line of duty. The hotel filled up completely when Roosevelt arrived for his summer vacation at Sagamore Hill. In September 1902, President Roosevelt designated September 15 a special day for the citizens of Nassau County and the villages of Cold Spring Harbor and Huntington to visit him at Sagamore Hill. The village decided to make it a special holiday. The schools were closed and arrangements made to present each visitor with a keepsake glass etched with "Sagamore Hill September 1902" and filled with lemonade. The Octagon Hotel was packed with Secret Service men and reporters. Between four thousand and seven thousand visitors shook Roosevelt's hand that day. On Election Day 1902, the president's secretary and his physician, who accompanied TR to

Oyster Bay where he voted, stayed at the Octagon after a late night with Roosevelt at Sagamore Hill.

In 1903, Baron Speck von Sternburg, the ambassador from Germany, stayed at the Octagon Hotel and drove out to Sagamore Hill to meet with President Roosevelt, becoming the first foreign diplomat to be presented to a president outside the White House. Secret Service men assigned to protect the president also stayed at the hotel.

The building remained a hotel for about twenty years more and then eventually became a car dealership. In later years, it was in bad condition and was almost demolished in 2008. A recent restoration has created a faithful replica of the original.

WELL VERSED ON LONG ISLAND

Over the years, Long Island has been home to some eminent poets and writers. Plenty of artistic types have made summer homes on the South Fork in the last few decades, but this "country house" phenomenon dates back much longer, to the year 1843, when noted writer, editor and poet William Cullen Bryant (1795–1878) looked to Long Island for a refuge. Bryant was a published poet by the age of thirteen, and his poem "Thanatopsis," which he wrote at sixteen, was the most famous American poem for decades. Bryant, who had moved to New York City in 1825 from his native Massachusetts, purchased a 1787 Quaker farmhouse along the eastern shore of Hempstead Harbor and turned it into a Victorian paradise, taking great pride in the landscaping and appearance of his property.

Tranquil Cedarmere was Bryant's retreat from the hectic life of New York City. Many mid-nineteenth-century celebrities visited Bryant at Cedarmere. The list includes actors such as Edwin Booth (brother of Lincoln assassin John Wilkes Booth) and Edwin Forrest; author James Fenimore Cooper; inventor Samuel Morse; poet Richard Henry Dana; artists Thomas Cole, Daniel Huntington, Robert Weir and Asher Durand; sculptor Horatio Greenough; and landscape architect Frederick Law Olmsted (who helped design the landscaping at Cedarmere and was one of the designers of Central Park).

In addition to being a local celebrity in Roslyn, Bryant was very active and well known in New York City. He was one of the founders of the Metropolitan Museum of Art, a champion for the creation of Central Park and editor and part-owner of the popular *New York Evening Post* newspaper.

The seven-acre property, located on the appropriately named Bryant Avenue, was donated to Nassau County in 1975 by one of Bryant's relatives. It sits almost as quietly today as it did in Bryant's era, a hidden retreat from modern life to this day.

Cedarmere was not the only land Bryant owned on Long Island. Bryant's other property in Roslyn is now the 145-acre campus of the Nassau County Museum of Art. Bryant's legacy lives on in Bryant Park in midtown Manhattan (so named in 1884) and William Cullen Bryant High School in Long Island City, which was built in 1889.

WHITMAN WASN'T WILD FOR WOODBURY

Walt Whitman, one of the country's most beloved poets, is closely associated with Long Island. His birthplace in West Hills (Huntington) has been preserved as a museum since 1949, helping to grow local pride for this independent spirit, who lived on Long Island on and off between his birth in 1819 and 1841, when he moved away for good.

His time on Long Island between 1836 (when he moved back to the island from Brooklyn) and 1841 was spent teaching at several different school districts, as well as founding a newspaper called the *Long-Islander.* Why did Whitman leave? Ultimately, Long Island may not have been urbane enough for Whitman, who spent time in New York and Washington, D.C. What may have pushed him over the edge and away from Long Island for good was his time teaching at a small schoolhouse in Woodbury. To say that Whitman was miserable in Woodbury would be an understatement, as is revealed in a series of letters that were only discovered in 1985 and were bought at an auction by the Library of Congress.

In July 1840, after having taught at Woodbury for only a few weeks, Whitman wrote to his friend Abraham Leech: "I believe when the Lord created the world, he used up all the good stuff and was forced to form Woodbury and its citizens out of the fag ends—the scraps and refuse—for a more unsophisticated race than lives hereabout you will seldom meet in your travels."

But Whitman was far from done with his Woodbury rants:

> *How tired and sick I am of this wretched, wretched hole! I wander about like an evil spirit, over hills and dales, through woods, fields, and swamps.*

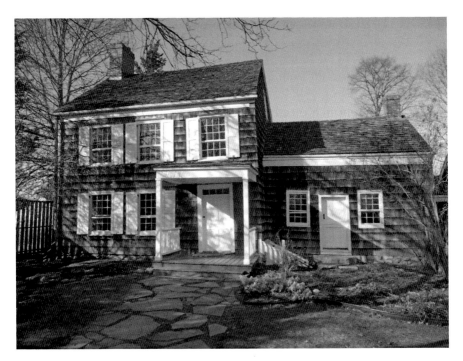

The home where Walt Whitman was born survives in Huntington Station and is a museum. *Author's collection.*

In the manufactory of nature, the building of these coarse gumpheads that people Woodbury, for surely no decent workman ever had the making of them. And these are the contemptible ninnies with whom I have to do, and among whom I have to live. O' damnation, damnation! Thy other name is school teaching and thy residence Woodbury. Time, put spurs to thy leaden wings and bring on the period when my allotted time of torment here shall be fulfilled. Speed, ye airy hours, lift me from this earthly purgatory; nor do I care how soon ye lay these pudding-brained bog-trotters, amid their kindred earth. I do not believe a refined or generous idea was ever born of this place; the whole concern, with all its indwellers ought to be sunk to chaos. Never before have I entertained so low an idea of the beauty and perfection of man's nature. Never have I seen humanity in so degraded a shape as here. Ignorance, vulgarity, rudeness, conceit, and dullness are the reigning gods of this deuced sink of despair.

When he was about to leave Woodbury in September 1840, Whitman had one last thing to say to his friend about the town:

I perform the thrice-agreeable office of informing you that my purgatory here is just finishing. In a few days, I shall be unbound and unloosed....O, how my spirit springs and grows elastic at the idea of leaving this diabolical and most particularly cursed locality! Shades through which I have wandered, orchards that I have plundered, old school room, dirty-faced urchins, and moth-eaten desk, I bid ye all a long farewell. Pork, cucumbers, and buckwheat bread, we must part, perhaps forever! Solemn thought! Rye-sweetcake, sour milk, and "scented" fish, ye dear companions of the past summer, alas! The mouth that has known you will know you no more.

So what became of the schoolhouse where Whitman taught? In 1927, when the building was to be demolished to make way for a new, larger school, it was purchased for sixty dollars by the wealthy Alexander Moss White Jr. and moved to his estate in Oyster Bay Cove, where it sits today. The desk that Whitman used at the Woodbury school is at the Walt Whitman Birthplace.

THE LONG ISLAND FARMER POET

Long Island has seen its share of quirky personalities, but Bloodgood Haviland Cutter (1817–1906) of Little Neck is very near the top of the list. The wealthy Cutter, who dressed in old-fashioned clothes, spoke in verse and was known to carry his Bible on the streets of Little Neck, was known as the "Long Island Farmer Poet" because of his propensity for writing poems by the hundreds, on almost any subject, and often on the spot. He was a regular every year at the Mineola fairgrounds, where he wrote verses on the flowers, ladies, produce and bicycle races, among other things. The newspapers poked gentle fun at him for the never-ending verse that poured from him on all occasions, yet gave him affectionate attention. Of his poem "The Bicycle Race," which began with the verse, "I gazed on the bicycle race / As they went round with rapid pace / With bended backs-heads held low / At a tremendous speed did go," the *New York Times* wrote that the "sport was better for it." The *Oswego Daily Times* proclaimed, "Cycling like other sports, should have its great epic poem. 'Casey at the Bat' amply fills this want for baseball, and the lovers of the wheel look to Mr. Cutter to woo the muse in their behalf."

His moniker "Long Island Farmer Poet" was not just a casual or occasional nickname; it was a proper title that was used every time he was mentioned

in the newspapers. In 1886, he paid to have a five-hundred-page book of his poems published. But he was known not only for his poetry. In 1894, he bought the old former Queens County Courthouse building (at Herricks Road near Mineola) at auction for $800. He would later offer it to the bishop of the Episcopal Diocese of Long Island for use as a home for children and invalids.

Cutter's most famous encounter was with Mark Twain, whom he met on a five-month steamer cruise to the Holy Land in 1867. Twain was amused at Cutter's propensity to recite endless verses to his fellow passengers. Twain later immortalized Cutter in his book *Innocents Abroad* (1869), referring to him with tongue in cheek as the "Poet Lariat." Twain wrote: "Well, I didn't expect nothing out of him. I never see one of them poets yet that knowed anything. He'll go down now and grind out about four reams of the awfullest slush about that old rock (Gibraltar) and give it to…anybody he comes across first which he can impose on. Pity but somebody'd take that poor old lunatic and dig all that poetry rubbage out of him." Cutter wrote about Twain, too: "One droll person there was on board, The passengers called him 'Mark Twain'; He'd talk and write all sort of stuff. In his queer way would it explain."

Upon his death, Cutter bequeathed the Long Island Historical Society his books—all six thousand of them. He had a fortune of $1 million when he died; $750,000 of that went to the American Bible Society, and the remaining $250,000 was divided among more than two hundred heirs.

Remembering Cutter in a 1936 article in the *Nassau Daily Star*, a reporter summed it up: "His writings were ridiculed and made the butts of jokes. I too, admit that I called him Bloody Cutter—I who would like to have so much a life record the equal of his."

CABIN IN THE WOODS

William Cullen Bryant's retreat was a large house on a large estate. But not all writers prefer such grandiose settings. In fact, another Long Island poet and author preferred to do much of his writing in a tiny, hewn pine one-room cabin he built for himself. Christopher Morley published more than fifty books, including novels, poetry and plays. He also edited *Bartlett's Familiar Quotations*. In 1920, Morley, who had most recently lived in Hempstead and Queens Village, moved to an estate called Green Escape in Roslyn Estates. In 1934, Morley built the "Knothole" on his property as a retreat. The quaint

Christopher Morley's hand-hewn one-room cabin now stands in Christopher Morley Park in Roslyn. *Author's collection.*

and old-fashioned cabin had an interesting ultramodern feature: a one-piece preassembled "dymaxion" bathroom that was designed by the architect and scientist Buckminster Fuller (known for his design of the geodesic dome) in 1936. The tiny, energy-efficient module separated and shrink-wrapped solid waste for later composting.

Nine years after Morley's death, in 1966, the Knothole was moved to its current location just north of the main entrance and parking lot of what is now Christopher Morley Park on Searingtown Road in Roslyn. It sits unassumingly off a park trail, backed up against woods, indeed looking very inviting for writing. Christopher Morley would approve.

As an interesting side note, Morley's publisher, Doubleday, Page & Company, was headquartered in Garden City, where the firm had moved in 1910 (the new building was dedicated by Theodore Roosevelt). The impressive complex (with extensive landscaped gardens) was able to produce sixty-five hundred books per day when it opened; by 1930, it could turn out forty thousand books a day. More than seven hundred employees worked for Doubleday. The adjacent Country Life Press railroad station was at the time used to ship the books and magazines.

LONG ISLAND'S ABOLITIONIST MINISTER

The home of one of the country's earliest and most vocal abolitionists stands quietly, unmarked, on a dead-end street in a hidden corner of Jericho wedged between Route 106 and Jericho Turnpike on what is known as Old Jericho Turnpike. The structure is still in existence only because it is part of the twenty-acre Jericho Historic Preserve, created in 1972 by Nassau County executive Ralph Caso to protect some of the last remaining eighteenth-century buildings in the area.

Jericho was first settled in the seventeenth century by Quakers, and one hundred years later it was still very much a Quaker settlement. The Hicks house was built in 1740 by Jonathan Seaman and his wife. Their only child was a daughter named Jemima (1751–1829). She met and married a young man from a good local family, Elias Hicks. For Hicks, meeting and marrying Seaman was a turning point in a life that he realized had been too filled with wickedness, such as dancing. In 1771, the couple married at the Westbury Meetinghouse and then decided to move in with their in-laws in Jericho. As he wrote in his autobiography:

> *I was born in Queens County, Long Island, on the north side of the great plains, generally known by the name of the Hempstead Plains, about three miles west of the meetinghouse at Westbury....In the spring after our marriage, my wife's relations gave me an invitation to come and live with them, and carry on the business of their farm, they having no other child than her. I accepted this proposal, and continued with them during their lives, and the place afterwards became my settled residence.*

Soon after moving to Jericho, he realized that his calling was to the ministry. He became an important fixture in the community and helped build the Jericho Meeting in 1788. Before that, the local Quaker population had to travel to Westbury to attend meeting; now they had their own place of worship that was only a two-minute walk away.

Elias Hicks was quite strong in his opinions and his belief that they needed to be heard. He traveled extensively observing other Quaker meetings and speaking. In 1784, he made a grand tour of the various Friends meetinghouses, attending meetings at Herricks, Hempstead Harbor, Hempstead, Huntington, Patchogue, the Fire Place, South Hampton, North Sea, Amagansett, Montauk, Sag Harbor, Shelter Island,

South Hold, Oyster Pond Point, Setauket and Stony Brook. He also toured more distant places such as Ohio, Pennsylvania, Maryland, Indiana and New Jersey.

Hicks was staunchly antislavery from an early age, and in 1778, he freed his own slaves and set out to convince his Jericho neighbors to free their slaves. By 1777, 85 slaves had been freed, and by 1791, 150 local slaves were freed. Hicks was a member and top contributor of the Charity Society of the Jericho and Westbury Monthly Meetings (formed in 1794), which benefited the poor members of the African American community. In 1811, Hicks published a powerful antislavery essay in which he proceeded to ask and answer a series of questions: Were not the people of Africa, at the time when the Europeans first visited their coasts, a free people, possessed of the same natural and unalienable rights as the people of any other nation? What measures can be adopted by the legislature and citizens of New York in order to exculpate themselves from the guilt of that atrocious crime of holding the Africans and their descendants so long in slavery? In 1824, he said, "We are not better for being white; than others for being black." The home of Hicks's son-in-law Valentine Hicks, directly across the street, was

The Elias Hicks House still stands in a quiet corner of Jericho. *Author's collection.*

a stop on the Underground Railroad. (The home, built in 1789 and during the twentieth century a popular restaurant called the Maine Maid Inn, was gutted and is currently undergoing a major renovation.)

Hicks's fiery lectures and his many travels helped spread his fame. The poet Walt Whitman was impressed by Hicks and had occasion to hear him speak, as he recounted in 1888 in a piece called "Anecdotes About Elias Hicks":

> *Though it is sixty years ago since—and I a little boy at the time in Brooklyn, New York—I can remember my father coming home toward sunset from his day's work as carpenter and saying briefly, as he throws down his armful of kindling blocks with a bounce on the kitchen floor, "Come, mother, Elias preaches tonight"…and as I had been behaving well that day, as a special reward I was allow'd to go also.*

Hicks's sermons were famously controversial. Of Hicks, Whitman wrote: "Others talk of Bibles, saints, churches, exhortations, vicarious atonements—the canons outside of yourself and apart from man—Elias Hicks to the religion inside of man's very own nature. This he incessantly labors to kindle, nourish, educate, bring forward and strengthen. He is the most democratic of the religionists—the prophets."

The Elias Hicks House has most recently been used by the Mothers Centers of America and other nonprofits. On the day that I visited, there was no sign of anyone around. It looked eerily abandoned, yet there were signs that it had been occupied recently. There was a post in front, next to the mailbox, with an arm and two hooks, where a sign had apparently once been hanging. A lone rooster roamed the property, which includes an ancient barn at the northwest corner. The rooster was both skittish and aggressive, perhaps protective of the old Hicks place, which looks very much the same as it did in a photograph taken in the nineteenth century. Quiet, peaceful, hidden…ironically the home of one of early nineteenth-century Long Island's most outspoken and well-known people.

Chapter 4

RAILS, ROADS AND RUNWAYS

T ransportation firsts are plentiful on Long Island, the site of the oldest continuously operating railroad system in the country, the nation's first limited-access concrete highway and the very first U.S. airmail flight, among many other historic moments and events. In this chapter, we'll search for stories and physical remains of Long Island's record-breaking transportation history.

THE LAST TURNPIKE TOLLHOUSE

Travel in early nineteenth-century Long Island ranged from slow going to slower going. What today takes minutes by car took hours back then, by horse-drawn carriage or wagon. Residents of what is now central Nassau County who wanted to get to New York City at least had Jericho Turnpike to take them straight to Jamaica (and from there they could get to the city fairly easily), but residents of the North Shore had no simple way to head west. Instead, they had to go out of their way and head south before proceeding west to New York.

Finally, in the 1830s, a decent east–west road was constructed along the North Shore, leading from Roslyn through Manhasset, Great Neck and Bayside to Flushing, from whence they could get to New York. To raise money for constructing the road, stock shares were sold for twenty-

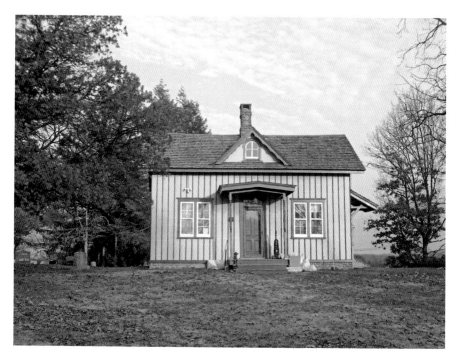

A mid-nineteenth-century tollhouse within the Roslyn Cemetery. It is used as a private residence. *Author's collection.*

five dollars by the North Hempstead and Flushing Road and Bridge Company (founded in 1835). Though the route itself still exists (more or less) as Route 25A, Northern Boulevard, all traces of the original turnpike are gone—except one.

Of the many tollhouses on the route, the Gothic Revival–style East Gate Toll House still stands today. It is the only surviving nineteenth-century tollhouse on Long Island. The toll in 1860 was a whopping one cent (twenty-nine cents in today's money). So where exactly is this tollhouse located? If you guessed in a cemetery, you'd be dead right! It is located in the middle of the historic Roslyn Cemetery. Located on Northern Boulevard just west of the intersection with Glen Cove Road, this cemetery is the burial spot for the writers William Cullen Bryant (1794–1878; newspaper editor and poet), Frances Hodgson Burnett (1849–1921; creator of Little Lord Fauntleroy) and Christopher Morley (1890–1957; novelist).

Construction of the cemetery began in 1861 on four acres of land not far from the four-room, twenty-seven-foot by seventeen-foot tollhouse, which was built in 1860. The turnpike alignment shifted, and the cemetery

eventually expanded to fourteen acres, surrounding the old tollhouse. By the twentieth century, the dilapidated building was used as a shed, but it was restored in 1975–76 and is currently serving as a residence.

It was pretty easy to find the tollhouse once I knew where to look. When you enter the cemetery from Northern Boulevard, pull off to the side. The tollhouse will be quickly visible to the right, on a little rise. The board and batten (vertical siding) construction is fairly rare. The building is listed in the National Register of Historic Places, hiding in plain sight among a multitude of gravestones near the intersection of two of the busiest roads in Nassau County, one of which it originally and faithfully served, collecting Indian head pennies from wagon drivers.

TRAIN MEETS CAR

Long Island earned a dubious distinction on the morning of October 30, 1901, when the at-grade rail crossing at Post Avenue in Westbury became the site of the first collision of a train and a car in the United States. And it was no ordinary Joe whose car was wrecked. It was a famous race-car driver named Henri Fournier who happened to be driving across the railroad tracks in his brand-new, $9,000, yellow French-made Mors automobile (the equivalent of $240,000 today!). He was driving at a whopping six miles per hour when his car was struck by an oncoming train identified as Engine No. 53, traveling from Mineola east toward Hicksville at forty miles per hour. Fournier was heading north on Post to Jericho Turnpike, from whence he would go west, back to New York City. He and his party of five had just been at the Meadow Brook Hunt Club, where they spent time with the wealthy car and horse enthusiast William K. Vanderbilt, who was very interested in the new machine his fellow racer was showing off. Vanderbilt was on his way home, and his car had led the way and was north of the train tracks when the accident happened.

The five passengers of Fournier's ill-fated car included A.G. Batchelder, cycling editor of the *New York Herald*, and J.H. Gerrie, a reporter from the *New York Journal*—which is perhaps why this event was recorded for posterity! Another passenger was H.B. Fullerton, manager of the publication department for the Long Island Rail Road. The other passengers, Arthur Lewis and H.J. Everall, were friends of Fournier who had come along for the day's fun.

Reports of why Fournier and his passengers did not hear the warning bell ringing at the crossing are not consistent. By some accounts, the bell did not ring at all. In one story, Fournier admits that the car's engine was so loud it drowned out the sound of both the warning bell and the train's bell, which was also ringing. The one thing that is certain is that the crossing was completely obscured by trees and four two-story houses that were close to the tracks, making it impossible to tell a train was approaching by sight alone.

"I had just reached the crossing," said Fournier, "and the front wheels of my machine were just touching the first rail, when the locomotive loomed up, and I realized that an accident was inevitable. Not having time to reverse the power, I gave the handle a quick turn, which moved the front wheels to the right, and then the Crash came. The locomotive struck the machine two or three inches behind the left front wheel, throwing it around so that the rear of the automobile was brought against the locomotive."

The car itself was launched into the air and flew a distance of fifty feet from the impact, sending its passengers flying as well. Fournier and one of the passengers were thrown a distance of about fifty feet, while two others were thrown one hundred feet into a nearby field. The remaining two were thrown a few feet from the wreckage of the car. Miraculously, Fournier suffered only a sprained ankle and some scrapes. Fullerton was the most seriously injured, suffering a fractured skull and remaining unconscious for at least twelve hours after the accident. Others suffered cuts and broken bones. Vanderbilt raced back to the scene of the accident to offer assistance. All six injured men were taken to Nassau Hospital (now Winthrop University Hospital) for treatment.

"The first thing that I remember is somebody calling and asking me if I were dead," said Fournier. "I think I was unconscious for about a minute. The machine was completely demolished. It was not one of my racing machines. It was of only ten horse-power, very heavy and was built to hold six persons."

By most accounts, he saved lives by quickly turning the car parallel to the train. "I feel danger and follow my instinct rather than my reason," he said at the time. "It was my instinct which saved the lives of my companions and myself." Passenger Everall agreed: "Nothing but the coolness of Fournier saved us all from instant death."

The day after the accident, Fournier had plans to sue the railroad for $50,000 in damages, saying he would be incapacitated for a long time, but that prediction seems not to have been correct. Just seventeen days after the

accident, Fournier set a new speed record, going a mile in just under fifty-two seconds at Coney Island.

As for the railroad crossing, a bridge was soon built to eliminate the grade crossing and prevent any further incidents. Grade-crossing elimination is still one of the Long Island Rail Road's primary objectives, as there are still plenty of them left across the island.

THE LONG ISLAND MOTOR PARKWAY

Long Island is the birthplace of the world's first limited-access highway. The Long Island Motor Parkway (also known as the Vanderbilt Motor Parkway) was the brainchild of William Kissam Vanderbilt Jr. (1878–1944), who came from an old-money family. His grandfather Commodore Cornelius Vanderbilt (1794–1877) was responsible for the construction of the original Grand Central Terminal. William was an automobile enthusiast at a time when few people owned cars. In 1901, he had briefly held a speed record when he drove his Mercedes five miles in a time of about seven minutes (a little more than forty miles per hour). His Vanderbilt Cup Races (see chapter 5), held on Long Island's ramshackle roads beginning in 1904, were his impetus for creating a smooth, safe, dustless road.

The ambitious project, the planning for which began in 1906, sought to create a seventy-mile-long road through central Long Island, from near the Queens/Nassau border all the way to Riverhead. One of the biggest challenges was obtaining the property, or right of way, to build the parkway. Farmers and estate owners had to be convinced to allow a road to be built through their land. Any holdouts would mean an expensive and inconvenient shift in the roadway's course.

The highway was touted as a great place for automobile designers and manufacturers to test their cars under "true road conditions." From the beginning, the parkway was envisioned as a highway for the wealthy. After all, at that time, before the Ford Model T, automobiles were still only affordable for the privileged. The investment prospectus for the motor parkway explains: "The numerous golf, fishing, yachting, and shooting clubs will be conveniently and speedily reached and can be more fully made use of by their members."

Besides being the country's first concrete highway, one of the other unique features of the parkway was its complete grade separation

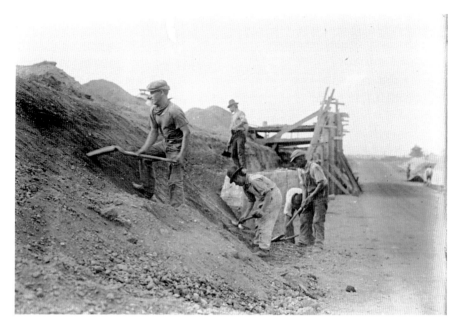

Workers banking the Long Island Motor Parkway, 1910. *Library of Congress.*

from other existing roads. All streets and railroad tracks were crossed above or below grade, which meant there were many bridges along the parkway—sixty-five to be exact.

On June 7, 1908, the first ceremonial shovelful of dirt was turned over with a gold spade in Bethpage in front of several hundred spectators. The president of the Automobile Club of America said on the occasion: "All hail, those pioneers—Mr. Vanderbilt and his associates—who for the motorists of America and the world are thus blazing the trail for the motor roads, the motor streets, and the motor bridges of the future."

Work progressed at a moderate pace. In September 1908, a race-car driver named Joe Tracy tested the completed portions and was able to reach sixty miles per hour on the turns and one hundred miles per hour over a straight stretch. "The cement highway makes an excellent racing road, because it is absolutely dustless, and on account of the grayish color does not blind the driver even in the glaring sun," said Tracy.

Construction was rushed so segments of the parkway could be completed in time for the 1908 Vanderbilt Cup Race, which would be held in part along the new highway. About nine miles of roadway were complete by the end of 1908, from Westbury to Bethpage. In 1909, the parkway was extended west

from Westbury to Mineola and east from Bethpage to Dix Hills. The section from Bethpage to Lake Ronkonkoma was opened in 1910.

This expensive new highway was not to be free for motorists. The toll on the Long Island Motor Parkway was originally set at $2.00, then fell to $1.50, $1.00 and finally $0.40 in the 1930s. There were twelve toll lodges at entry/exit points along the way (connecting to nearby local roads), some of them designed by famous architect John Russell Pope (designer of the Jefferson Memorial).

The years that followed the opening of the parkway saw an increase in Long Island's population and the construction of the more modern, higher-capacity Northern State Parkway in the early 1930s. This new highway quickly rendered the narrow Long Island Motor Parkway obsolete, and it was sold to New York State for $80,000 in 1938 (a fraction of the $6 million it had cost to build thirty years earlier).

Most of the historic old highway was completely demolished over the years, as new infrastructure, homes and commercial development were built. Still, there are a surprising number of remnants of this engineering wonder left across Long Island. Though miles of the roadway's easternmost alignment have been preserved as County Route 67 (and known as the Vanderbilt Motor Parkway) from Dix Hills to Ronkonkoma, this is a new road that simply follows the path of the old one.

Remnants of original roadway, of varying lengths and in varying states of preservation, can be found all across Queens and Nassau Counties, and in the course of writing this book, I set out to find many of them. A major section of original roadway (with two of the original bridges) has been preserved as a very pleasant walking trail and bike path within Alley Park and Cunningham Park in Queens.

Other preserved traces run through Nassau County, including some that serve as a right of way for Long Island Power Authority power lines. The best-preserved segment in Nassau County lies in Albertson/Williston Park, on either side of Willis Avenue. The western portion is now called Highway Drive, unaccessible to us mere mortals who do not work for the North Hempstead Highway Department. But across the street on the east side of Willis Avenue, the old parkway is now an access road for parking lots—and thus the only drivable section of the original Motor Parkway left! Farther east from this spot, just west of Roslyn Road, a stretch of Long Island Motor Parkway about a quarter mile long exists up an embankment just south of Croyden Court. Covered with tree limbs, weeds and debris, the original parkway pavement is still visible. Little strips of roadway and

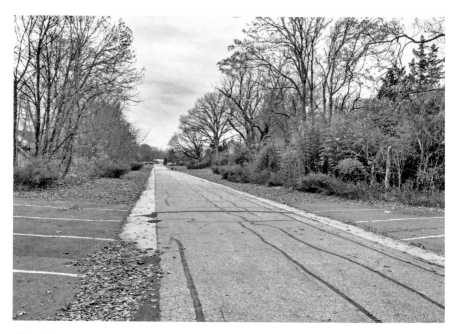

Above: The only drivable stretch of original remaining Motor Parkway, on the border of Williston Park and Albertson, just off Willis Avenue. It provides access to parking lots. *Author's collection.*

Below: The Long Island Motor Parkway's Garden City toll lodge, moved from its original location to Seventh Street just off Franklin Avenue. *Author's collection.*

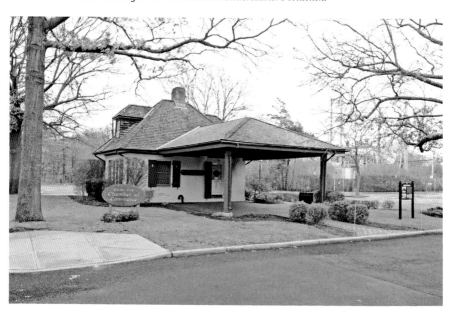

concrete parkway posts can be found all over. Vanderbiltcupraces.com is a great resource for those looking to locate and explore all the various remaining segments.

Several of the original toll lodges still exist today. One in Mineola and another in Williston Park have long since been converted into private residences and greatly altered. The best-preserved lodge is the Garden City lodge, which was moved from its original location at Clinton Road and is now the headquarters for the Garden City Chamber of Commerce, on Seventh Street off Franklin Avenue.

Beginning in 2007, a proposal was put forth by Nassau County to create a Motor Parkway Trail that follows the old Long Island Motor Parkway alignment where possible. The trail, for hikers and bikers, would take the overgrown sections of roadway, preserve and interpret them and create recreational uses for them. It will be interesting to see if this piece of Long Island's hidden history will soon be brought back into the full light of day for all to enjoy.

Abandoned Rails

The development of Long Island is closely connected to the coming of the railroad. The Long Island Rail Road (LIRR) was one of the first railroads in the country. First formed in 1834, the system's tracks reached Hicksville by 1837. Tracks were laid farther and farther east, with new stations opening every year. The first service to Greenport was begun in 1844. This was the "main" line, which ran through central Long Island. Other branches were eventually built, the first of which split off from Mineola and went south to Hempstead by 1850. A northern branch-off from Mineola to Glen Cove was begun in the 1860s.

By the early twentieth century, rail tracks crisscrossed the island, but by the middle of the century, financial concerns and shifting demographics caused many stations to be abandoned. In total, close to fifty LIRR stations have been closed and abandoned over the years.

While in many cases it was just stations that were abandoned, in others, entire branches were shut down. For example, the LIRR's Rockaway Beach Line, leading south from Rego Park to the Rockaways, was abandoned in 1962. Another abandoned line is the old Central Branch of the LIRR, which ran from Garden City to Bethpage. This line was

part of what used to be Garden City founder A.T. Stewart's vintage 1870s Central Railroad of Long Island, which originally ran from Flushing to Babylon. The Central Railroad was acquired by the LIRR a few years after it was built, and some sections are still in use today. The Central Branch was personally important to Stewart because it allowed him to transport bricks from his brickworks in Bethpage west so he could build his new development of Garden City. Stations added along the way over the years included Meadowbrook (opened 1873, closed 1939), which served the Meadow Brook Club and its fox hunts, golf and polo matches; and Mitchel Field (opened as Camp Black Station in 1896, closed 1953), which brought people to the army air base. Regular passenger service on the Central Branch, whose tracks ran through what is now Eisenhower Park, ceased in 1939. For a few years, a shuttle train service ran for a few stops between Country Life Press (in Garden City, opened in 1911 to serve the Doubleday Publishing Company on the Hempstead Line) and Mitchel Field, but all passenger service ended in 1953. Stops on the abandoned line included one for the *Newsday* facility (opened 1949, closed 1953) and one for the supermarket A&P (opened 1928, closed 1953).

Abandoned railroad tracks on what was once the Long Island Rail Road's Central Branch, Garden City. *Author's collection.*

An abandoned Central Branch railroad trestle stands hidden in the woods just off the Meadowbrook Parkway. *Author's collection.*

The Central Branch's remnants are one of the best-preserved and most easily accessible stretches of abandoned track on Long Island. The remaining tracks run east–west between Franklin Avenue in Garden City (where it splits off from the Hempstead Branch line) and E Road in East Garden City, just west of Endo Boulevard, for a distance of about twelve thousand feet (a total of just over two miles). A walk along the tracks reveals it is littered with train-related debris, including pieces of coal of various sizes, numerous rail spikes and fragments of wooden ties. Note that this section is not completely abandoned and has been used once a year to bring the Ringling Brothers Barnum & Bailey Circus train to Nassau Coliseum and very occasionally for LIRR maintenance trains.

My daughter and I were standing on the abandoned tracks taking photos when we thought we saw something out of the corner of our eyes. We looked up, and it was a train's headlights coming at us from the west. The train, which looked ominously large and shadowy, was bearing down on us! And yet only a moment earlier I had been looking in that direction and had seen nothing. Wow! So much for abandoned tracks! Hearts pounding, we quickly

stepped off the tracks and moved through a row of hedges to the adjacent strip of grass to wait for the train to pass. A minute went by—nothing. We ventured back out and peeked to the left. Nothing! All we saw were cars crossing the tracks at a distant rail crossing. We exchanged a puzzled glance. We could not possibly have both imagined seeing a train. So if it was not our imaginations, what was it? Some kind of creepy ghost train? I racked my brain as we walked along the tracks to where we thought the train had been. Was it this close? Or did it just look this close? And then as I stood there, I remembered—the tracks are active just a little farther to the west before they veer off to the south toward Hempstead. That must have been what we witnessed. It looked like a train was headed our way, and when we moved, it turned and was gone. At least that is what we have officially told ourselves.

This strip of rail tracks also happens to feature what is probably the only old station left along Long Island's abandoned lines, the Clinton Road Station at the intersection of Clinton Road and St. James Street North in Garden City. Built in about 1911, likely to serve the many new homes being constructed in the area, passenger service to Clinton Road ended in 1953. The building, still in excellent condition, is now being used as Station No. 3 by the Garden City Fire Department.

Aside from stations and long stretches of track, you may also encounter sections of old, unused tracks in the most random places, including parking lots. Many of these are private industrial "spurs" or short jags off a railroad mainline that lead to a factory or industrial facility, allowing freight trains to deliver and ship materials. There were also rail spurs that led to psychiatric hospitals, such as the now defunct Kings Park and Pilgrim State, bringing supplies and visitors.

Aviation Pioneers

While Kitty Hawk, North Carolina, was the actual birthplace of airplane flight, in 1903, the aviation industry really took off on Long Island. Most people know about Lindbergh's historic flight from Roosevelt Field in 1927. But how did Long Island become such an aviation hot spot?

Early twentieth-century central Nassau County (encompassing parts of Garden City, Mineola, Carle Place, Westbury and Uniondale) was ideal for flying because the level, mostly treeless Hempstead Plains was perfect for airfield construction. It was also not very populated, which meant that large

parcels of land were available and that flights could be conducted without any danger to people on the ground. This area of Long Island became known as the "Cradle of Aviation" because of its important role in early aviation. But who was responsible for building the cradle that helped grow little Baby Aviation into a healthy youngster? It was a man named Glenn Curtiss (1878–1930), an aviation pioneer who had successfully flown his plane *June Bug* more than five thousand feet in Upstate New York in 1908, winning the Scientific American Trophy.

The next year, Curtiss was commissioned (for $5,000) by the New York Aeronautical Society to build and demonstrate a plane for its use. The *Golden Flyer* (nicknamed the "Gold Bug") was made of spruce and bamboo, and on June 29, 1909, Curtiss flew it at the society's field in the Bronx, becoming the first person to fly a plane in New York City. The society wanted to use its Bronx field as the site of all kinds of aviation experiments, but Curtiss told them it was too small. He went to Long Island to locate a more suitable plot of land. The society suggested the Hempstead Plains as the ideal place for a flying field. "I looked over all the suitable places around New York City and finally decided upon Mineola, on Long Island. The Hempstead Plains, a large, level tract lying just outside Mineola, offered an ideal place for flying," Curtiss wrote.

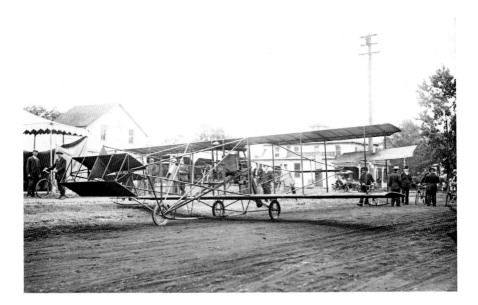

The Curtiss *Golden Flyer* in Mineola, 1909. *Library of Congress.*

On his recommendation, the society leased the land, just east of Washington Avenue and just south of Old Country Road, from the Garden City Company, and within mere days the field was ready for flight. It was Long Island's first flying field. Curtiss was hoping to win the Scientific American prize again. He did a few test runs before attempting to try for the prize, which was to be given for a flight of at least 25 kilometers. He laid out a triangular course of 1.3 miles. On July 13, 1909, he flew his plane for 1.5 miles in three minutes, the first successful flight on Long Island. The next day he flew it 5 miles; on July 15, 6 miles; and on July 16, 15 miles. He and his plane were ready to try for the prize!

According to Curtiss:

It was a memorable day for the residents of that particular section of Long Island, who had never seen a flying machine prior to my brief trial flights there a few days before. They turned out in large numbers, even at that early hour, and there was a big delegation of newspapermen from the New York dailies on hand. Flying was such a novelty at that time that nine-tenths of the people who came to watch the preparations were sceptical while others declared that "that thing won't fly, so what's the use of waiting 'round." There was much excitement, therefore, when, at a quarter after five o'clock, on the morning of July 17, I made my first [official] flight. This was for the Cortlandt Field Bishop prize of two hundred and fifty dollars, offered by the Aero Club of America to the first four persons who should fly one kilometer. It took just two and a half minutes to win this prize and immediately afterward I started for the Scientific American trophy.

He flew the course twelve times, completing the 25 kilometers in thirty-two minutes, and then he decided to keep flying. By the time he landed, he'd flown the course nineteen times for a distance of 24.7 miles, setting a new record and taking home the $10,000 prize for his efforts. Aviation was no longer just a strange new experiment. Airplanes were here to stay. Importantly, for the first time, someone other than a Wright brother had successfully flown a plane on a long-distance flight, and it happened on Long Island.

Curtiss's field, known as the Mineola Airfield, or the Washington Avenue Airfield, became a popular spot for aviation enthusiasts from all around the region. In 1911, Harriet Quimby learned to fly at Washington Avenue and became the first licensed female pilot in the country. Thanks to Curtiss, other flying fields on Long Island soon opened, including the

350-acre Nassau Boulevard Airfield in Garden City, which opened in 1910 and had thirty-one hangars.

In 1917, Curtiss opened the Curtiss Engineering Corporation facility at the western end of Hazelhurst (soon to become Roosevelt) Field. It was the world's first facility devoted to aeronautical research and testing, and it included an impressive ten-foot-diameter wind tunnel. This facility was where the Navy-Curtiss NC-4, a four-engine flying boat (aka seaplane), was developed. In 1919, it would become the first plane to cross the Atlantic (with stops along the way). The Curtiss building still exists at Stewart Avenue and Clinton Road in Garden City and is now used by Nassau BOCES. The original circa 1929 smokestack also stands, with the letters "CURTISS" running vertically along the length still faintly visible.

THE FIRST AIRMAIL

As aviation continued to make advances, Frank Hitchcock (1867–1935), postmaster general of the United States, dreamed of a day when mail could be delivered using airplanes. And why not? It seemed logical. How efficient this would be! Mail could get to its destination in a fraction of the time it took by land. Hitchcock saw his chance to try this idea during an aviation meet at the Nassau Boulevard Field in 1911. A special postal tent was set up on the fairgrounds of the International Aviation Tournament for attendees to write postcards and be part of the historic flight. Realizing the historic opportunity, people swarmed to this booth. On September 23, 1911, after being officially sworn in as the Post Office Department's first airmail carrier, pilot Earle Ovington (1879–1936) took off in a Bleriot XI airplane with a seventy-five-pound sack of mail containing 640 letters and 1,280 postcards. He had to place the bag on his lap, because there was no place else for it in the plane. Less than ten minutes after he took off, he touched down safely at Mineola.

But minutes after Ovington had taken off, a coincidental tragedy caused much confusion when a strikingly similar plane appeared in the sky, trying to make bold moves. When this mystery plane tried to climb and bank at the same time, the plane tipped over and wound up in a deadly nosedive, striking the ground near the grandstand. For several agonizing minutes, everyone thought it was Ovington before they figured out it was a novice flyer named Clark who had no license but wanted to show off to the crowds.

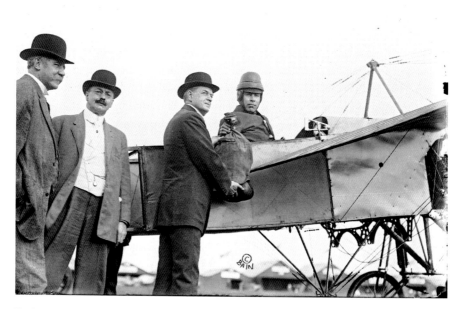

Earle Ovington receives the first bag of airmail from U.S. postmaster general Frank Hitchcock at the Nassau Boulevard Aerodrome International Aviation Meet, Garden City, 1911. *Library of Congress.*

When Ovington returned to the aviation meet, he was greeted with sighs of relief and pats on the back, which befuddled him until the accident was explained to him.

Ovington repeated his airmail delivery feat for several days while the fair went on. According to a memoir written by Ovington's wife, Adelaide, "The Postmaster at Mineola used to stand in the centre of the field and wave a red flag. When Ovie got five hundred feet above him, he aimed at the waiting official and dropped the bag, which always broke and scattered the letters. This seemed a funny way of 'defending the mails,' but Ovie said that it was necessary, as he did not dare make a landing with the bag on his knees." From Mineola, the mail would be routed on to its destination in the usual way, but it was not long before airmail flights were occurring all across the country.

The Mineola Field and Nassau Boulevard Field both closed in 1912, relocating to the one-thousand-acre Hempstead Plains Airfield (established in 1911 east of Clinton Road) in what is today East Garden City. Hempstead Plains Airfield was renamed Hazelhurst Field in 1917,

and the eastern end was renamed Roosevelt Field in 1919 (for Theodore Roosevelt's son Quentin, who had trained there before being killed in action during World War I). The western section of Hazelhurst became Curtiss Field in 1920. To the south of the original Hazelhurst Field was Hazelhurst Field No. 2. Opened in 1917, it was renamed Mitchel Field in 1918, after former New York City mayor John Purroy Mitchel, who had died that year in a military flight mishap in Louisiana.

THE RACE TO CROSS THE ATLANTIC

Though most everyone knows about Charles Lindbergh's historic flight across the Atlantic from Roosevelt Field in 1927, what has been mostly forgotten is that three other serious challengers almost had that honor.

The first challenger was a French World War I flying ace named Captain Rene Fonck (1894–1953), who spent much time at Roosevelt Field preparing for a transcontinental flight. Fonck set off in a Sikorsky model S-26 on September 21, 1926. The plane traveled about thirty-two hundred feet down the runway before it veered to the left. It was later speculated that the plane's load was simply too heavy. The plane skipped into the air only briefly. Captain Fonck tried to land the plane but was unsuccessful. The right wheel of the landing gear buckled and fell off, and the plane flipped onto its side. Fonck himself was not seriously injured in the accident, but the plane's radio operator died in the accident.

The fatal accident did not deter others from trying. Naval officer and explorer Richard E. Byrd had made his mark in history by becoming, in 1926, the first to fly over the North Pole. The success of this venture and the acclaim Byrd received propelled him to take on a new challenge: transatlantic flight. As with any true adventurer, the chance to be first was more of a motivation than the $25,000 prize that had been offered by hotelier Raymond Orteig for the first nonstop flight across the Atlantic between New York and Paris (in either direction). Byrd had obtained the financial backing he needed from department store owner Rodman Wanamaker and rented Roosevelt Field so he could make the attempt. In mid-April, he flew a test run of the *America*, a tri-motor Fokker plane, but it crashed at Teterboro Airport in New Jersey, wrecking its nose and central propeller and injuring Byrd. This was a serious setback. The plane would need repairs, and Byrd's arm would need time to heal.

Another potential transatlantic aviator, a pilot named Clarence Chamberlain, was seemingly ready. He and copilot Bert Acosta had taken off from Roosevelt Field on April 12, 1927, in their Bellanca monoplane *Miss Columbia* (loaded with 375 gallons of gasoline) for an endurance test flight in an attempt to break the record of forty-five hours. They wound up flying for fifty-one hours, back and forth over Long Island. The endurance flight won Chamberlain the backing of millionaire Charles A. Levine. Soon after, an unfortunate and badly timed disagreement arose within the Chamberlain team; a temporary injunction was issued, preventing the plane from lifting off.

An airmail pilot from the Midwest, Charles Lindbergh was a relative latecomer to the competition. His brand-new monoplane, the *Spirit of St. Louis*, flew for the first time on April 28, and he only headed for Roosevelt Field on May 10. Unlike the other two American competitors, Lindbergh intended to fly solo.

But the Americans weren't the only ones vying to be first across the Atlantic. French challengers Charles Nungesser and Francois Coli took off from an airfield near Paris, headed for New York, on May 8, 1927, but were never heard from again, their plane likely crashing into the Atlantic.

Preparations on Long Island continued at a frantic pace. All three challengers were hoping to be first. A May 13, 1927 headline in a Brooklyn newspaper read, "Three American Planes in Readiness for New York–Paris Flight." Byrd's plane had arrived on May 12 from Hasbrouck Heights, New Jersey, repaired and almost ready to go, though his wrist was not quite healed. Nobody was certain if and when Byrd might fly. The same could be said of Chamberlain, who was waiting for the injunction to be lifted. While Byrd's plane waited at Roosevelt Field, Lindbergh's and Chamberlain's planes were at neighboring Curtiss Field.

The photograph shown on the following page is a rare and historic snapshot taken at Roosevelt Field on May 15, 1927, showing Byrd emerging from the America Transoceanic Company's hangar, with his plane *America* in the foreground. Note the photographer perched on the roof of the hangar. The handwritten caption on the back says "Commander Richard E. Byrd may be seen walking out of the hangar with receptacles in his hands. He was first American to fly over 'North Pole' in 1925 [*sic*]. And contemplates flying from New York to Paris. Bert Acosta is the pilot." Acosta, originally part of the Chamberlain team, went over to Byrd's team once the legal troubles prevented Chamberlain from taking off.

It was Lindbergh who was ready to leave first. Though the weather was questionable on the evening of May 19, just before midnight Lindbergh

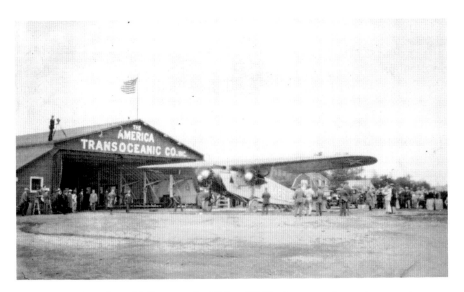

Transatlantic flight hopeful Commander Richard E. Byrd emerges from a hangar at Roosevelt Field and walks toward his plane, the *America*, May 15, 1927. *Author's collection.*

decided he would make the attempt the next morning. He slept for just two hours in his room at the Garden City Hotel and then arose at around 2:00 a.m. By the time Lindbergh arrived at the field, there was already a crowd of people waiting, including Byrd, who was there to wish him luck, waving goodbye and saying, "Good luck, old man, I'll see you in Paris." Lindbergh started down the runway at 7:52 a.m. For a few tense moments, it looked as if the plane would not lift off. Finally, the nose lifted, and the plane just barely cleared a tractor and then telephone wires. After thirty-three and a half hours in the air, Lindbergh's plane touched down in Paris. He was an instant hero.

Chamberlain's injunction was lifted, and he was ready to go on June 4. He became the second to fly across the Atlantic, the first with a passenger—his backer Charles Levine. His plane landed in Germany after nearly forty-six hours, flying three hundred miles more than Lindbergh had.

Byrd was not deterred from making the flight, and he was almost ready. By the time Lindbergh made a triumphant return to Roosevelt Field on the afternoon of June 16, 1927, after a day of appearances in New York City, Byrd still had not left. Escorted by police on motorcycles and followed by reporters, Lindbergh appeared before a crowd of twenty-five thousand people. He gave a speech about the importance of building new airports and then left to the cheers of his admirers.

Finally, on June 29, 1927, Byrd, Acosta and two others took off with eight hundred pounds of mail. They also carried two American flags to give to the president of France: a silk flag made by the great-great-grandniece of Betsy Ross with pieces of Ross's original American flag incorporated into it and the silk flag that Byrd brought with him when he flew over the North Pole in 1926. They arrived in France after forty-four hours but had to intentionally crash-land in the water due to fog.

So what became of Roosevelt Field after the historic flights? Just weeks after Lindbergh's historic flight, there were concerns about the long-term viability of the airfield. Plans were proposed to have the citizens of Nassau County buy and preserve the runway from which Lindbergh took off, as a monument to the accomplishment, and prevent it from eventually being sold into building lots. The plans fell through, but the field was safe for the time being. In fact, aviation grew by leaps and bounds after Lindbergh's landmark flight. Just four years later, in 1931, the famed Texas-born aviator Wiley Post took off from Roosevelt Field on a quest to break the record for flying around the world. He and his navigator, Harold Gatty, beat the old record of twenty days by twelve days, landing back on Long Island after only eight days.

The eastern section of Roosevelt Field (about 260 acres) was used to create the horse-racing track known as Roosevelt Raceway in 1936, but the western portion continued to operate as an airfield. Roosevelt Aviation College, which was headquartered there, had an enrollment of 1,500 students. More than 270 planes were stationed at the field by about 1940. During World War II, the airfields of the Hempstead Plains were a key part of the war effort, with soldiers being encamped there. The aviation school closed in 1949, and that was the beginning of the end. Roosevelt Field closed in 1951. All the aviation history was not enough to save the field, not even a sliver of it. These days, all that remains of Roosevelt Field is the name, bestowed upon the huge mall that was built on the site in 1956.

So where exactly is the spot where Lindbergh's plane took off? It's just outside the entrance to the parking garage of the Mall at the Source in Westbury, just south of Old Country Road. The spot is commemorated by a small stone monument depicting Lindbergh's plane, the *Spirit of St. Louis*, in flight.

FULL OF HOT AIR?

The first transatlantic flight of a lighter-than-air craft actually took place years before Charles Lindbergh, and it ended on the very same Long Island airfield where Lindbergh took off. The R-34, a 640-foot-long British dirigible with a crew of twenty, a cat mascot named Wopsie and two carrier pigeons (in case of emergency) left Scotland, headed for America, on July 2, 1919. The cat was given a last meal of sardines before leaving, to compensate for the strictly bread-and-water diet on the flight. The ship, 79 feet wide and 92 feet high, was equipped with five motors—two 250-horsepower and three 350-horsepower—and could achieve a maximum speed of sixty-three miles per hour.

The flight was more harrowing than had been anticipated. The R-34 had to survive fog, heavy winds and thunderstorms and had to divert from its planned course. The airship traveled 2,485 miles to Trinity Bay, Newfoundland, and from there south-southwest 1,215 miles to Mineola. The newspapers wrote of its adventures along the way, and all wondered if the ship would make it safely to New York.

Preparations for the airship's arrival were made at Roosevelt Field weeks in advance. Twenty piles of gas canisters were assembled to refill the dirigible. A silver sausage-shaped balloon was floated high above Roosevelt Field so the R-34 could find the landing field in case of fog. A grandstand was erected, and once the ship neared New York, all local hotels were full in anticipation. A staff of 750 army and navy men were on hand to help with the landing, and 2,000 military police were assigned to control the crowds.

The crew originally predicted a flight of 72 hours, but bad weather drove the flying time way up, and now the craft was running out of fuel. Upon arrival, it only had a fraction of its original 4,500 gallons of gasoline left, enough for only another 90 minutes of flight. When it finally arrived at Roosevelt Field on July 6, it had been 108 hours and 12 minutes since takeoff, a long time—but still an hour faster than the fastest crossing of the ocean liner *Mauretania*.

Just before the landing, one crew member, Major John Edward Pritchard, parachuted out of the airship from fifteen hundred feet to make landing arrangements. He signaled to his ship once the arrangements were made. The ship descended and then dropped a long rope. Soldiers on the airfield grabbed the rope and pulled, bringing the R-34 safely to the ground. Newspaper accounts of the time said it looked like a "huge flying fish." The next day, a strong gust of wind ripped the R-34 from its mooring, and it took

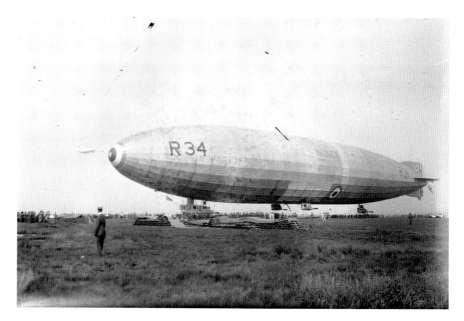

The mooring of the R-34 dirigible in Mineola, 1919. *Library of Congress.*

three hundred men to pull its ropes and secure it. It had to be a short stop at Roosevelt Field, since there was no hangar there (or anywhere in the United States) big enough to store the blimp.

The R-34 left Mineola to go back across the ocean at 11:59 p.m. on July 9. Before the ship left, Mrs. Thomas Edison went to Roosevelt Field to present a phonograph and fifty records to the R-34 crew on behalf of her famous husband, along with a congratulatory letter from him. The crew was also given six copies of the July 8 edition of the *New York Times* to deliver to King George and other dignitaries. On its way back home, the airship flew over Times Square around 1:00 a.m. and was illuminated by spotlights, passing just six hundred feet above the Times Building as a crowd of people below cheered.

RUNAWAY RUNWAYS

The massive Roosevelt Field and Mitchel Field were such huge parts of Long Island's aviation history for several decades. So what is left of what used to be two huge airfield complexes? Not much!

One of the main remnants of the area's air heritage are the names of some of its streets: Charles Lindbergh Boulevard and Earle Ovington Boulevard, for example, in Uniondale. Earle Ovington was an aviation pioneer who in 1911 became the Post Office Department's first airmail pilot, flying from Garden City to nearby Mineola. James Doolittle Boulevard, running north–south between Charles Lindbergh Boulevard and Hempstead Turnpike, was named after another aviation pioneer, James Doolittle (1896–1993). In 1929, he took off from and landed at Mitchel Field using instruments alone, without being able to see out the cockpit window—the world's first completely blind airplane flight. Quentin Roosevelt Boulevard was named after Theodore Roosevelt's son, who died in aerial combat during World War I.

As I said earlier, there are no physical remnants of the old Roosevelt Field. Nothing! The field from whence Lindbergh took off on his transatlantic flight was sold to a developer in 1951 and within a few years was completely developed, replaced by the Roosevelt Field Mall. Buildings and parking lots cover all traces of the flying field.

Mitchel Field, however, is another story. For years after it closed in 1961, the runways were still intact. As development of the property began in the mid- and late 1960s, the runways were dismantled piece by piece. The construction of Nassau Community College, the Nassau Coliseum and its parking lot, parts of Hofstra University, the Marriott Hotel and a network of roadways saw the gradual disappearance of the airfield.

As recently as 2006, there was still a fairly substantial length of Mitchel Field runway left; but since then, half of what was left was demolished to make way for more parking on the Nassau Community College campus. What remains today of Mitchel Field's runways are one small section of Runway 17/35 and two pieces of Runway 5/23. The southwestern portion of Runway 5/23 (the main runway), on the Hofstra University campus, was made into a parking lot, still on the same alignment as the runway. It connects to the southern end of the remnants of Runway 17/35, also parking. These are easily accessible but hardly recognizable as anything other than parking unless one looks at them from an aerial view.

The interesting remnant is the fairly extensive northeastern strip of what used to be the 6,700-foot-long (over a mile!) Runway 5/23 and part of its taxiway, hidden from plain sight by a ridge of tall Hempstead Plains grasses on the south, the Hempstead Plains Preserve itself on the east side and a ridge with trees on the west. Only from the north can the remains be glimpsed. I was excited to try to see this for myself; it looked very intriguing

in the aerial view I studied. I drove over to the Nassau Community College campus one autumn day and parked near where the runway was supposed to be. Thanks to my phone's GPS, I could figure out exactly where I was, always essential when you're trying to locate truly hidden history. I had to print out a satellite photo to bring along, because the regular map view does not show the runway remnants. It was a bit of a challenge to find a good access point to this hidden runway, but after a few minutes of exploration, I did. From behind a wall of shrubbery and down a slight embankment it unfolds, an otherworldly and eerily abandoned glimpse of a past that was such a dominant part of this area for decades. I entered on the taxiway, which was littered with traffic safety cones, and followed its curve northeast and around to the much wider main runway. It only takes a little imagination to envision planes taking off from here. What a strange and wondrous place, especially considering its tenuous future! Who knows if expansion or other plans by the county will see the destruction of the rest of the last runway?

The remains of a taxiway leading to the main Runway 5/23 at Mitchel Field, tucked near Nassau Community College. *Author's collection.*

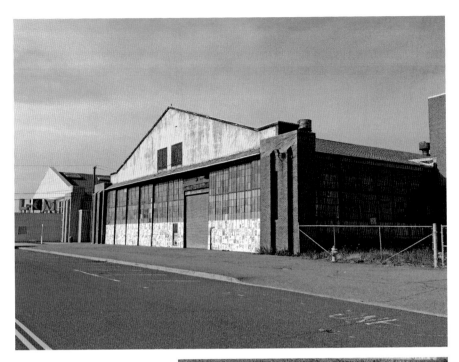

Above: One of several remaining hangars at Mitchel Field. *Author's collection.*

Right: A sign on the door of one of the original remaining hangars at Mitchel Field. *Author's collection.*

But this runway remnant is not only important because of the planes that once sped along its pavement. It is also the site of a historic scene that took place here in 1971, when one of the most famous moments of one of the most famous movies ever made was filmed on the spot. Though most people may not associate *The Godfather* with Long Island, the Sonny Corleone death scene, which was actually supposed to take place at Jones Beach, was filmed on the remnants of Runway 5/23. The filmmakers painted white lines and constructed a vintage-looking tollbooth in this deserted-looking locale. The scene shows Corleone's car coming from the runway in a southwest direction and then turning left onto the taxiway and pulling up to the tollbooth. Other cars follow and trap Sonny, then the gangsters open fire, filling him full of lead, as the old saying goes. It is one of the most dramatic cinematic moments in the history of film. In the background of the scene, you can actually see the television tower that is located adjacent to the campus of Kellenberg Memorial High School.

Besides runway remnants, there are also several hangars that remain intact, some used by the Cradle of Aviation Museum and the Long Island Children's Museum.

THE BRIDGE TO NOWHERE

Infrastructure that serves no purpose is not likely to survive for long on modern Long Island. Real estate is a precious commodity, and so, as we've already seen in this chapter, survival is rare, and often quite hidden from public view. One remnant of the past, however, is seen by thousands of motorists every day. Anyone who drives along the Meadowbrook Parkway just south of Hempstead Turnpike passes under an abandoned bridge without even knowing it. From below, it looks like any other parkway bridge, but from above it is another story entirely.

The story begins in the early 1940s, during World War II, when the Mitchel Field Base was in full swing and more space was needed. Adjacent land to the southeast of Mitchel Field (parts of which were formerly the Coldstream Golf Course) was purchased and used to build a sub-base called the Santini Base. One of the main buildings on Santini was a hospital that treated the war injured. Other buildings on the base included a chapel, an enlisted men's club, an officers' club, bachelor officers' quarters, a mess hall and a post office. All told, there were more than fifty buildings on the

The Meadowbrook Parkway Santini Base Bridge adjacent to Kellenberg Memorial High School in Uniondale—a bridge to nowhere. *Author's collection.*

base, which extended from Hempstead Turnpike to two blocks south of Front Street.

In 1954, the construction of the Meadowbrook Parkway (running north–south) split the base in two pieces. Thankfully, a bridge over the new highway was built to allow vehicles and pedestrians to cross quickly between the two halves. A few years after the base closed in 1961, a piece of the land was acquired by the Diocese of Rockville Centre, and a Catholic high school called Maria Regina opened there in 1961, right on the western side of the Meadowbrook. The school property included land across the bridge on the eastern side of the parkway, as well. The school closed in 1984 and was reborn as Kellenberg Memorial High School in 1987. Today, the abandoned bridge sits off a hidden path just north of the entrance to the Telecare television studio. The tree- and shrub-lined winding dirt path rambles on for a bit and finally lets out at the bridge, which was used for students to access a now mostly abandoned ball field on the other side. Standing on the bridge, which used to carry army vehicles filled with soldiers, elicits a strange feeling. Isolated and abandoned, yet directly above one of Long Island's busiest highways, the bridge is the last remaining trace of a once-bustling air force base.

Chapter 5

HORSES AND COURSES

Because of its proximity to New York City and its wide-open spaces, Long Island has a long history of use as a playground for the wealthy, who made their homes in the hilly northern half of the island and played on the flat expanse of the Hempstead Plains. In this chapter, we'll uncover some of the hidden history of sports such as horse racing, polo, golf and auto racing that have thrived on Long Island over the years.

HORSE RACING

Long Island was the birthplace of American thoroughbred horse racing, a heritage that goes back more than 350 years. In his 1670 book *Brief Description of New York*, Daniel Denton wrote:

> *Toward the middle of Long Island lyeth a plain 16 miles long and 4 broad, where you will find neither stick nor stone to hinder the horses heels, or endanger them in their races, and once a year the best horses in the island are brought hither to try their swiftness, and the swiftest rewarded with a silver cup, two being annually procured for that purpose.*

The course that Governor Richard Nicholls had laid out just five years earlier, which he named the Newmarket or New Market Course, had

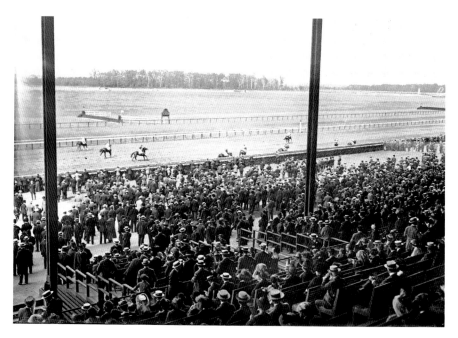

The start of a race at Belmont Park, 1912. *Library of Congress.*

already achieved fame. The silver cup mentioned by Denton was donated by Governor Nicholls in 1668. It is the oldest surviving piece of American colonial silver and also one of the oldest racing trophies in the world.

Racing continued to be popular through the eighteenth century, with many great races run on the Hempstead Plains. One such event took place in 1750, and spectators came from many miles away, including dozens who came from Manhattan, which was then an hours-long trip. It was estimated that the total number of horses at the races that day on the Plains exceeded one thousand.

One of the greatest horse races in Long Island history was a one-man race, against time. In March 1841, Isaac Willets, a stage proprietor from Hempstead, bet Gilbert B. Miller of Brooklyn $600 that he could drive a pair of horses hitched to a wagon 140 miles, from Brooklyn to Montauk Point, in twenty-four hours. The day of the race, Willets set out from Brooklyn at six o'clock in the evening and arrived at Montauk the next day at 5:02 p.m.—twenty-three hours and two minutes later…the last two hours of which were in a snowstorm. But as the story goes, Willets hired a large covered wagon to ride ahead of him those last 50 miles, which shielded him from the snow.

Aside from the New Market Course on the Hempstead Plains, there were other mile-long tracks on Long Island in the nineteenth century, including one in Huntington, another in Babylon and one in Massapequa. But these early racecourses were crude in comparison with what was to come in the twentieth century. The most famous racetracks in Long Island's more recent history are Belmont Park, which is where the final race of the Triple Crown is held every June, and Roosevelt Raceway, which closed in 1988.

LADY SUFFOLK

The most famous horse in Long Island history was Lady Suffolk, also known as the Old Gray Mare (whose color became white as snow in her old age). Born in Smithtown in 1833, she was sold to David Bryant as a two-year-old for $112.50 and began her racing career in 1838 at a track in Babylon. She met with immediate success, winning the race, with its purse of $11. In 1845, she became the first horse to run a mile in under two minutes and thirty seconds. In 1847, she was the first horse to win a race at the new track

Seen here in an 1852 Currier and Ives print, Lady Suffolk was Long Island's most celebrated horse. *Library of Congress.*

at Saratoga, New York. In 1849, when she was an ancient sixteen years old, she ran in twenty races. She was so widely known that she went on a tour of several cities in 1850 and was the subject of a Currier and Ives print in 1852. She raced until the age of nineteen. The song "Old Gray Mare" is supposedly about Lady Suffolk. An offer of $5,000 for the star horse was made and refused. Her overall record was an astonishing 90 wins and 56 second-place finishes in 163 races (many of them two-, three- or even four-mile races), and she earned $35,000, which was a fortune in the mid-nineteenth century.

THE HUCKLEBERRY FROLIC

The Washington Race Course (also known as New Market or Salisbury Plains) was located northwest of Hempstead Village, about two miles south of Mineola, just southwest of what is now the intersection of Cathedral Avenue and First Street on the border of Garden City and Hempstead. Besides races, which were held there since colonial times, the Washington Race Course was the site of the infamous Huckleberry Frolic, a free carnival-like festival held every year during the first week of August, when the huckleberries were ripe. Horses would come from as far away as Brooklyn, Babylon and Huntington, starting from home in the morning to get to the track by early afternoon. The horses would trot for the whole afternoon and often way past sundown. The prize money for the races was collected by someone walking around the crowd with a tumbler, in which people would put either one, two or four shillings. The purses were not very large. In 1861, the highest value was twenty-five dollars for the second race, featuring three horses: Contest, Champion and Kate. The small two-story judges' stand on the track was crudely constructed, with the judges on top and a bar on the bottom floor. After each race, the crowd was encouraged to have some gin (with huckleberries mixed in) and sugar rum or brandy. An 1865 account of the event said: "The usual amount of strong drink was imbibed, and of course, as it was fighting whiskey, it was necessary to have a few fights, but nothing serious occurred." After the races were over, everyone would make a mad dash for their horse and wagon and rush over to Hempstead Village to Steve Hewlett's Hotel on the corner of Main Street and next to St. George's Church for more drinking.

Besides the horses, there was plenty of other entertainment. At the 1846

frolic, for example, there were horse races, foot races, sack races, tumblers, fire eaters and wild animals from the Arabian desert and the Siberian mountains. Bull baiting was also attempted at the frolic, and on one occasion the bull broke loose and became entangled in the spectators' chairs surrounding the track. In the chaos of the aftermath, pickpockets struck and stole much property. The popular festival developed a reputation for its profanity, obscenity and "every conceivable wickedness and abomination." At some point, though, things changed, for in 1878 it was reported that there was a notable absence of "that boisterous merriment and unlimited drinking which formerly characterized Huckleberry Frolic." Not long after that, as growth of the area continued, the land was sold and developed, and the Huckleberry Frolic was no more.

POLO COMES TO LONG ISLAND

Born in Westbury in 1860 to a wealthy family, Thomas Hitchcock Sr. was a gifted equestrian from an early age. Horses were his passion, so when a new equestrian sport was introduced to America in 1876, Hitchcock was fascinated. This "new" sport was actually an ancient one played by nomadic Asian warriors over two thousand years ago. Hitchcock was instantly hooked on this sport, whose modern version had been introduced in India in 1859. Just a teenager, he helped organize the first ever polo match on Long Island in 1877, and in 1879, he played before ten thousand spectators in the first public match in America. His efforts (along with three others) led to the formation of the famous Meadow Brook Polo Club in Westbury in 1881 (located just south of Stewart Avenue and adjacent to what would later be Mitchel Field). Hitchcock soon became one of the sport's first ten-goal players, the equivalent of a .400 hitter in baseball.

In 1890, Hitchcock purchased an old Quaker farm just north of Jericho Turnpike in Westbury and transformed it into an equestrian's dream come true. To complete the vision of this estate, which he called Broad Hollow, Hitchcock built an extensive stable complex, a greenhouse and an impressive eight-furlong (one-mile) track on the property, as well as a polo field and steeplechase course. So impressive was the track that it was clearly marked on a 1906 map of the entire Nassau County (as well as 1927 and 1939 maps), possibly the only private track of its size on Long Island. Though not used in decades, the outline of the track is still visible

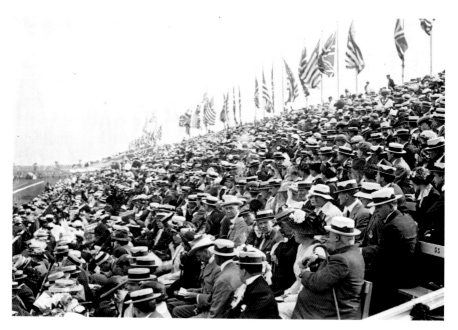

A crowd watches a polo match at the Meadow Brook Club, 1914. *Library of Congress.*

today in Google aerials.

Besides his polo prowess, Hitchcock was known for his interest in training horses to jump. He was, in fact, considered the father of steeplechase horse racing. This interesting sport involves not simply racing but jumping as well. Hitchcock trained many prizewinning horses at Broad Hollow, patiently teaching them to jump over fences. Broad Hollow was also the starting point for many a fox hunt, an extremely popular sport among the wealthy horse set. Among his other accomplishments, Hitchcock was one of the founders of the famous Belmont Park in Elmont. He owned and trained a horse named Good and Plenty, which was racing's leading earner in 1904, 1905 and 1906. Good and Plenty won the 1906 American Grand National at Belmont and was inducted into thoroughbred racing's hall of fame in 1955.

The Hitchcock family split their time between Old Westbury and Aiken, South Carolina. To say horses were his life would be an understatement. In 1916, Hitchcock and his wife risked their lives to blindfold sixteen horses and lead them from their burning stable.

The Hitchcocks had several children, including a son named Francis, a daughter named Helen and another son named Tommy (born in 1900). While all of the Hitchcock kids had athletic talents, Tommy was very special.

But it was not so much his famous father who trained him. It was his mother, Louise, also a talented polo player. It didn't take long for the handsome, ambitious kid to live up to his potential. He was destined to outshine even his illustrious father. With access to the best-trained horses a few steps away from his front door, it wasn't long before Tommy was ready for the spotlight. He played in his first polo tournament at the tender age of thirteen and was on the winning team of the U.S. National Junior Championships at age sixteen. World War I interrupted the horse ambitions of both men, who held interesting distinctions: at age fifty-seven, Thomas Sr. became Major Thomas Hitchcock, in charge of the aviation field at Mineola. He was the oldest aviator in the U.S. Army. At age seventeen, Thomas Jr. was Corporal Tommy Hitchcock, the youngest aviator in the army, flying missions in Europe and shooting down two enemy planes before getting captured by the Germans. His capture made newspaper headlines and doubtless caused much worry to his parents.

Miraculously, Tommy escaped from a German prisoner transport train

The ruins of Thomas Hitchcock's stables at Broad Hollow Farm, Old Westbury. *Author's collection.*

and, when the war ended, was back home. After attending Harvard, starting in 1921, he had a stretch of twenty years when he was arguably the world's best polo player. His name was synonymous with athletic excellence, and he was the talk of society. He was called the "blond Babe Ruth of American polo" in the 1920s. In fact, he was the model for the F. Scott Fitzgerald character Tom Buchanan in *The Great Gatsby* (1925) and Tommy Barban in *Tender Is the Night* (1934). A copy of *The Great Gatsby* signed to Hitchcock by Fitzgerald sold for $61,000 at auction in 2010.

During this time, Meadow Brook's polo matches attracted tens of thousands of people and drew the rich and famous as both spectators and participants.

With his son making his own fame and fortune, Thomas Sr. remained steadfastly dedicated to Broad Hollow and his horses. Though the family wintered in Aiken, South Carolina (where his wife had a tragic riding accident and died in 1934), they returned to Broad Hollow every spring. Even into his late seventies, Hitchcock Sr. never stopped training horses, long after his playing days were over. To the very end, he was enthusiastic about working with his animals. He died suddenly of a heart attack at his Broad Hollow estate in 1941, at the age of eighty, as he walked into his living room just minutes after training his horses to jump.

Unfortunately, Tommy's story did not end happily. In 1944, only three years after his father's death and recently retired from professional polo playing, Lieutenant Colonel Hitchcock was killed during a test flight of a new fighter plane, the P-51 Mustang, over England.

The golden years of Broad Hollow were over. Though the family remained there for another several years, they sold the property in the 1950s. For a time, Broad Hollow served as a training facility for local horse racers. The property changed hands several times, and it was a drug bust during a government sting in the 1990s that resulted in the property being seized and put up for auction. It sold for a relatively cheap price of $5.6 million to the Diocese of Rockville Centre. Why would the Catholic Church want to buy an equestrian estate? See chapter 7 for a continuation of the story.

A-HUNTING THEY WOULD GO

The Meadow Brook (aka "Meadowbrook") Hunt club was very popular

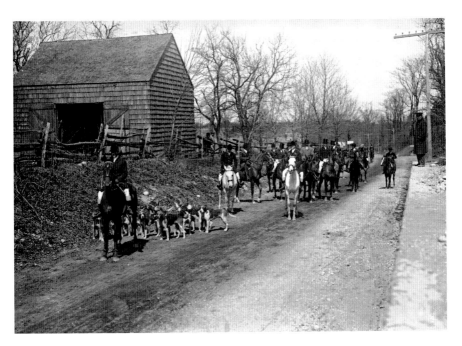

The Meadow Brook Hunt, 1912. *Library of Congress.*

among the rich and famous in the late nineteenth and early twentieth centuries. It was first informally created in 1879 in Mineola and officially founded in 1881. Headquartered in Westbury, about where Stewart Avenue and Merrick Avenue intersect, the club convened at various rural locations in Nassau County, especially where the hunting hounds and horses would be able to run free, but it was headquartered in Westbury. In 1886, the Meadow Brook Hunt met at the home of member and future president Theodore Roosevelt in Oyster Bay. Roosevelt once wrote: "When I was a member of the Meadowbrook hunt, most of the meets were held within a dozen miles or so of the kennels: at Farmingdale, Woodbury, Wheatley, Locust Valley, Syosset, or near any one of twenty other queer, quaint, Long Island hamlets." Roosevelt explained the motivation for fox hunting: "The fox is hunted merely because there is no larger game to follow. As long as wolves, deer, or antelope remain in the land…no one would think of following the fox."

One member of the club was appointed as the MFH (master of fox hounds) to lead the charge over several miles of terrain. An 1889 hunt covered fifteen miles and took an hour and forty minutes. The exciting sport was sometimes

dangerous, as falls from galloping or jumping horses could cause injuries or even death. For example, in October 1892, thirty-one-year-old Charles Cottenet was killed after he fell from his horse while riding between Jericho and Westbury. In 1908, Jackson Dykman lay unconscious for three hours in Hempstead after being thrown from his horse until a farmer found him.

Hunting of actual foxes was not always practiced. Instead, the club often performed "drag hunts," in which the hounds followed the scent of anise seed that was laid out for them (hounds have a strong attraction to this smell). The Meadow Brook Club, partly due to the terrain of the area, preferred the drag hunt. It was difficult to coax the foxes out of the woods and into the open fields where they could be more successfully chased. The Meadow Brook Club members did not want an indefinite chase; they wanted it to "end with certainty in time for dinner," according to one 1897 book.

The hunt was still popular into the 1930s. On New Year's Day 1932, one hundred members of the club met in Glen Cove for a chase through several North Shore estates. The Meadow Brook Hunt finally faded away in the 1940s, as development took hold of much of the open land in central Long Island.

RUN, OSTRICH, RUN

The Mineola Fair, held annually since the mid-nineteenth century at the fairgrounds (located where the Nassau County Courthouse complex now sits, off Old Country Road and Washington Avenue), was a popular destination, an exciting few days of attractions and races. Produce of all kinds was displayed, as were farm equipment, carriages and wagons (and, later on, automobiles). There were competitions to judge the best cattle, horses and pigs, among others. Sometimes there were special and interesting displays and performers, such as Arab tribesmen from the Sahara Desert performing tumbling and pyramids, as well as an exhibition of the Whirling Dervish.

But perhaps the most bizarre of all was when ostriches raced at the fair. When this happened in 1908, chaos resulted as an ostrich escaped from its handler. A headline in the *New York Herald* screamed, "Ignorant of Peril, 400 Chase Ostrich." It seems that Fleetwing, one of the larger of the six ostriches that had been shipped to Mineola from Tampa, Florida, for the occasion, shook off its blindfold hood as it was being uncrated. It escaped and proceeded to jump over a three-foot fence and then was off on a mad

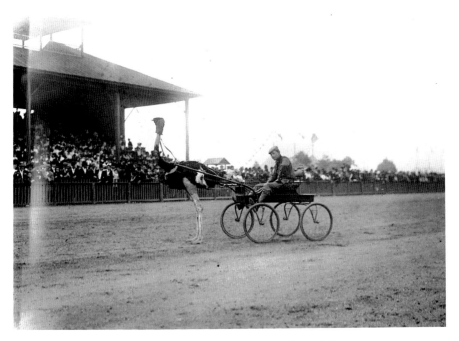

A racing ostrich at the Mineola Fairgrounds, circa 1908. *Library of Congress.*

dash across the fairgrounds. According to the newspaper article: "Ignorant of the fact that ostriches have kicked men to death, some four hundred persons to-day joined in a chase of a trotting ostrich at the Mineola fair grounds." The ostrich managed to elude capture for two hours, until it was cornered by a driver named William Ford, who tried to warn the crowd to stay back, telling them that the big bird posed grave danger. Sadly, it was he who was injured. "As Ford approached the bird dashed at him, landing a blow on his chest with one foot and knocking him down. Before the bird could do more harm a crate was thrown over him," continued the article. Despite this, Ford did not seem angry about the incident. He explained that the ostrich was likely restless after the long railroad trip. Fleetwing raced that day, against an ostrich named Fleetfoot, despite the earlier incident. A newspaper article a few days later commented on the races: "The ostrich races have not proved an entire success. The birds seem un-reliable and not exactly fitted for race track work. One bird valued at $2,000 banged its head Tuesday so that it died. However they are an interesting attraction."

The 1908 incidents did not prevent ostriches from returning to the fair. The 1915 fair featured a race of an ostrich hitched to a horse against a horse

harnessed to a sulky on a half-mile track. The ostrich, owned by Mrs. J.T. Landry of Covington, Louisiana, was considered the greatest racing ostrich in the world. Blitzen held the speed record: one minute for a half mile.

AT THE FORE!-FRONT

Though some form of golf had been played in America since the 1700s, it was not until the 1880s that the first true golf course was constructed in the United States. Long Island's first golf course, at Shinnecock Hills, was laid out in 1891. Just five years later, it hosted the country's second U.S. Open.

Over the next few decades, golf really took off on Long Island. Golf clubs sprang up everywhere, and many of the finest hotels built their own courses to accommodate their affluent guests. Clubs that had previously been dedicated to other sports, such as polo or fox hunting, now added golf to their menu of offerings. By 1939, there were about two dozen golf clubs in western Nassau County alone. Though many of these clubs are no longer

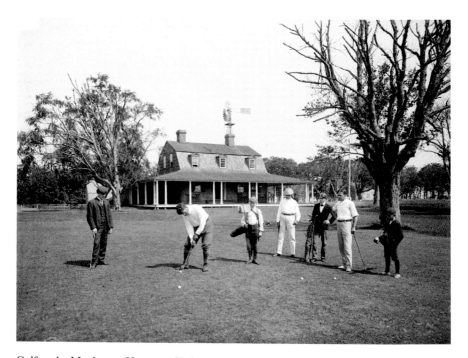

Golf at the Manhanset House on Shelter Island, 1904. *Library of Congress.*

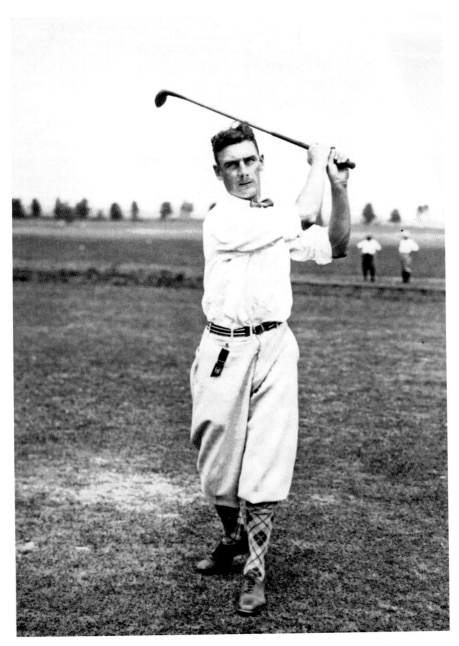

A golfer competing in a tournament at the Salisbury Club, 1925. *Author's collection.*

in existence, Long Island is still host to some of the nation's finest courses.

One of the island's best golf clubs was the Salisbury Club, at Salisbury Plains (Westbury), which opened in 1917 after the Garden City Hotel outgrew its course. The new Salisbury Club, built on open plains a few miles away from the hotel, had five courses. In 1926, the PGA Championship was held on the "Red" course at Salisbury (designed by famous golf architect Devereux Emmet), with the legendary Walter Hagen taking the title, the third of his four consecutive PGA titles. In 1939, the club was taken over by Nassau County in a tax sale, and in 1944, plans were announced to redevelop the club into the county's first recreation center. It opened in 1949 and was renamed Eisenhower Park in 1969. The original Red golf course would remain, and two additional courses were designed by another famous golf architect, Robert Trent Jones. The original circa 1917 clubhouse and other buildings still stand in Eisenhower Park.

Another of Long Island's public courses originated in a private club. Bethpage State Park, home of the "Black" course that opened in 1936 and was the site of the U.S. Open in 2002 and 2009, was originally the Lenox Hills Country Club before it was purchased by the Bethpage Park Authority in the 1930s. It was then turned into a park and revamped to include five courses. The Black course has been named the No. 1 public course in the country.

WHAT A CATCH!

Long Island has been the birthplace of many major-league baseball players over the last 170 years, including some recent stars, such as Smithtown native and lifetime Houston Astro Craig Biggio, who was inducted into the Baseball Hall of Fame in 2015, and Steven Matz, the young pitching phenom who was born in Stony Brook.

But the Long Island native who had the biggest impact on baseball was an unlikely hero, forgotten in the sands of time but who single-handedly (literally) changed the way the game was played. A Civil War veteran named Nathaniel Woodhull Hicks, born in Hempstead in 1845, began playing professional baseball in 1872, when, as a catcher, he joined the New York Mutuals (part of the National Association, which predated the National League). At the time, pitchers threw the ball underhanded, and catchers, barehanded and unprotected, stood about twenty or twenty-

five feet behind the batter. The only problem was that the Mutuals' star pitcher, Candy Cummings, had developed a new pitch: the curveball. Cummings loved throwing this pitch, but it would skip away and a`llow runners to advance. So Hicks decided to do the unthinkable. Instead of staying back, he stood right behind the batter and caught the ball with no mask, chest protector, shin guards or glove! Was this only when Cummings pitched? Yes, but Cummings was the team's only pitcher and pitched every single game!

Hicks took a beating, for sure. A *New York Times* account from 1876 tells of a game Hicks started with an already swollen face from being hit by a foul ball, "his right eye almost knocked out of his head and his nose and the whole right side of his face swollen to three times their normal size." He proceeded to be hit four more times—once on the mouth and once on the chest with the ball and twice with the bat—but he refused to leave his position. Hicks's injuries were not only due to catching. In one 1873 game, he stood up for himself against an umpire who questioned his integrity. The umpire grabbed a bat and hit Hicks in the arm, fracturing it and causing him to miss the rest of the season.

Before long, all catchers were right behind the plate, and the game started to look much more like the one we know today. It was also thanks to Hicks and Cummings that gloves were introduced for catchers, who began to follow suit and move up behind the batter. At the time of his death, Hicks was remembered as a true pioneer and fine catcher. "His feats are unequaled," lauded the *Times* in 1907.

THE HOUSE THAT RUTH BUILT

Quebec native Joseph Lannin was a rich man. He owned the Boston Red Sox between 1913 and 1916 and was the one responsible for buying Babe Ruth's contract from a minor-league team. Ruth, at the time a pitcher, went 18-8 in 1915 and 23-12 in 1916, helping lead the Red Sox to the World Series both years. Lannin also bought the Providence Grays in 1915, and with it came pitcher Carl Mays (who led Boston in saves and games finished in 1915). All this success increased the value of the team tremendously, and when Lannin sold it after the 1916 season, he made such a large profit that, in the end, the new Red Sox owner had to sell the team just to pay Lannin back.

Among Lannin's other investments was the Garden City Hotel on

The Dorothy Lannin house, built in 1930, is in Eisenhower Park. *Author's collection.*

Long Island, as well as nearby Roosevelt Field, from whence Lindbergh took off on his transatlantic flight in 1927. The Garden City Hotel had its own golf course, but by 1914, it had outgrown it. Lannin bought a parcel of land farther east and built the public Salisbury Golf Club, with five courses.

Lannin died at the age of sixty-two in 1928 after a mysterious fall from the eighth floor of a hotel in Brooklyn, leaving a fortune valued at $7 million to his two children, Paul and Dorothy. In September 1929, Dorothy married Harry Tunstall. With the help of the Lannin fortune, they built an impressive thirty-room, $60,000 mansion 1,500 feet from the Salisbury Club and furnished it to their taste. Then they went away on their honeymoon to Europe. Strangely, a bizarre tragedy befell this large mansion just one day before they returned in October. Despite caretakers having just checked the home and deemed it fit for the returning couple, a mysterious fire began just after midnight. Firefighters responded to the scene, but the nearest fire hydrant was off, and its valve was inaccessible inside the mansion's basement. The building was lost.

The Tunstalls proceeded to build another mansion in its place, an

ornate Tudor-style gem, though considerably smaller in size than the original. Finished in the spring of 1930, this building still stands today, near Merrick Avenue and south of Eisenhower Park's main entrance. It has been used for several purposes over the years, including serving as the Nassau County Historical Museum starting in 1961. It housed some aviation artifacts, seemingly fitting, since its former owner's father had owned Roosevelt Field. This seed collection was the foundation for the Cradle of Aviation Museum. The building is now home to the Billie Jean King Women's Sports Foundation.

The Vanderbilt Cup Races

Some of the biggest events in automotive history took place on Long Island, beginning when the main form of traffic on its roads was still horse and carriage. In 1903, racing trials were held on Long Island for the Gordon Bennett Cup Race in Ireland. The racecourse ran a length of six miles from Westbury south to Merrick.

The first international road race, held on Long Island in 1904, was the idea of one of the country's biggest automobile enthusiasts, William Kissam Vanderbilt II. The event was to be called the Vanderbilt Cup Race, and its start/finish line was in Westbury. Vanderbilt donated the prize, a $2,000 engraved sterling silver cup. The total length of the racecourse was about 285 miles (a total of ten laps around the course).

The racecourse went from Westbury, where a grandstand capable of holding one thousand people was constructed, to Jericho, then south to Hicksville, Bethpage and Hempstead. From Hempstead, the racers were to proceed into Queens, through Floral Park, then through Mineola and back to the finish line in Westbury along the Jericho Turnpike. Some residents of the area were opposed to having cars zoom by on their local roads; a letter with 188 signatures was sent to the race's board of supervisors, but to no avail. A notice was posted along the course warning people of the upcoming event and telling them to mind their small children and "chain your dogs and lock up your fowl." The supervisors said the race would make Nassau County "one of the most talked of localities in the country." The entry fee was a steep $300, half of which was returned if the car actually started the race. Preparations were extensive, and the newspapers had stories about the upcoming race on an almost daily basis for weeks. Days before the race,

William K. Vanderbilt's Mercedes at the grandstand of the Vanderbilt Cup Race in 1908, in what is now Levittown. *Library of Congress.*

crude oil that was spread across the road in Hempstead caused an uproar among homeowners, as the sticky black goo was tracked into their houses and onto expensive carpets. The odor of the oil was also a complaint, as was the fact that horses' legs were getting splattered with oil.

The race started at 6:00 a.m., so spectators had to arrive quite early in the morning. Some adventurous fans even ventured out along the racecourse and crossed the road between passing race cars. The winner of the 1904 race was George Heath, an American-born British citizen living in France. He was driving car No. 7, a French-made Panhard & Levassor that operated on four cylinders and had a seventy-five-horsepower engine. Heath finished the course in a time of five hours, twenty-six minutes and forty-five seconds, averaging a little more than fifty-two miles per hour over the entire race. Second place went to A. Clement Jr., driving a ninety-horsepower Clement Bayard, less than two minutes behind the leader's pace.

The race should have continued, but after the second car came across the finish line, the crowd began to leave, blocking the racecourse and ignoring Vanderbilt's pleas to clear the way. The race had to be stopped. It was a success overall, except for a racer who was injured when his car overturned, and his mechanic, who was killed. Still, the *New York Times* proclaimed, "The

contest was not as exciting as a horse race…for long stretches of time there was nothing to be seen," but it went on to say, "and yet it was an impressive sight….These ugly-looking mechanical demons whizzed by so fast that often they were nothing but a streak."

The race was held again the next year, and the entry fee was raised to $500, with no refund. That year, the average speed of the winner was more than sixty miles per hour, with at least one driver hitting almost ninety miles an hour on the straightaway. George Heath, the 1904 winner, finished in second place. The crowds were large—in 1905, 100,000 people watched the race. The earliest documented use of a checkered flag to signal the end of an auto race was in the 1906 race. In this same race, a spectator was killed by a race car, and mounting pressure about public safety led Vanderbilt to start building his Long Island Motor Parkway, which was begun in 1908, with the dual purpose of being a racecourse and a toll highway. Despite this, in the 1910 race, four people were killed. It was the last time the race was held on Long Island.

Development on the island and the ever-increasing speed of the new race cars made it impossible to continue to race on Long Island's roadways. But that was not the end of racing on Long Island. In 1936, a new, closed racetrack was begun in Westbury, on the site of Roosevelt Field No. 1, the one from which Lindbergh had taken off. Present at the dedication ceremony on June 12, 1936, was Kermit Roosevelt, son of Theodore Roosevelt and brother of Quentin Roosevelt (who had died in World War I), after whom Roosevelt Field had been named. An American Airlines plane landed on the field as part of the celebration; several pilots who had used Field No. 1 were in attendance.

Roosevelt Raceway marked the return of the Vanderbilt Cup (now called the George Vanderbilt Cup) to Long Island. The course was built in just eighty-three days, and the track was tested in September 1936, when thousands of cars, both racers and leisure drivers, ran the course for the first time. Though originally set for 400 miles, the race was cut to 300 miles in length because of the difficulty of the course. The course included a 3,775-foot-long straightaway that allowed cars to reach speeds upward of 150 miles per hour.

More than forty racers took part in the first official race on October 12, 1936. The field included such well-known racers of the time as Wild Bill Cummings and Billy Winn. A crowd of more than fifty thousand witnessed the race from the multi-tiered grandstand. The illustrious board of judges for the race included Mayor Fiorello LaGuardia of New

York City, Edsel Ford (son of Henry Ford), Kermit Roosevelt and Harvey Firestone (the tire company magnate). The winner of the contest was Tazio Nuvolari, a forty-year-old Italian driving an Alfa Romeo, with a time of four hours, thirty-two minutes and forty-four seconds, at an average speed of nearly sixty-six miles per hour. Nuvolari received an engraved cup as well as a $20,000 prize.

After the 1936 race, the course was altered to increase the average speed. It evidently worked, because a German racer doing a test run in June 1937 hit a record 158 miles per hour on the course. A crowd of seventy-five thousand people witnessed the 1937 George Vanderbilt Cup. The *New York Times* hailed the race beforehand as the "greatest auto race in history," but Americans were very disappointed when the German racer Bernd Rosemeyer won the contest, with an average speed of 82 miles per hour.

In August 1939, a three-hundred-lap midget car race (the first national championship) was held at Roosevelt Raceway, but that pretty much marked the end of the raceway's automotive history for a while. The next Vanderbilt Cup race at Roosevelt Raceway would not be held until 1960, when it was sponsored by another member of the Vanderbilt family, Cornelius Vanderbilt IV. An American named Harry Carter won.

THE LONG ISLAND AVIATION CLUB

As mentioned in the previous chapter, aviation grew up on Long Island. New technology was tested, records were broken and military air bases were built. But Long Island was also the site of another thing entirely—aviation for sport. With the opening of the $300,000 Long Island Aviation Country Club in Hicksville in 1929, the United States had its first social flying club. The club was patterned after British flying clubs that were becoming popular across the Atlantic. Plans were made to open a string of these flying clubs around the United States, though it is not clear whether these plans ever got off the ground. Like a golf club, polo club or tennis club, it was focused on providing luxurious and relaxing surroundings for its members to "play" at the sport of aviation.

But this "play" was not just tinkering for amateurs. This club meant business. Record-setting female pilot Ruth Rowland Nichols was one of the club's founders; Charles Lawrence, president of the Wright Aeronautical Corporation, who designed the Wright Whirlwind engine, was club

president; and Charles Lindbergh was a charter member, paying $1,000 for the privilege, so he had a good place to teach his wife, Anne Morrow Lindbergh, how to fly. The grand opening of the Long Island Aviation Club in June 1929 was attended by eighty prominent figures in the aviation industry, including the assistant secretary of war for aviation and the assistant secretary of the navy for aviation. There were stunts and "dogfights" as well as the arrival and mooring of a 136-foot blimp from Ohio, flown by the vice-president of the Goodyear Zeppelin Company.

There were occasional accidents. In its first year, a Queens man had his arm mangled when he got too close to the propeller of a plane that had just landed. Besides flying, club members could lounge around by the swimming pool and play tennis.

Excursions and outings were a big part of the club's organized activities. In 1933, for example, seventy-eight planes from the club flew to Daytona, Florida, to watch or participate in a flying race. In 1934, twenty-five flying boats (seaplanes) flew to Lake Delta at Rome, New York, from the club in what would become an annual seaplane voyage. During World War II, a civilian air patrol squadron was stationed there, and club members tested new gimmicks the air force had to offer.

But with the changing times and a changing Long Island, the club was doomed. When the developer William Levitt started buying up nearby land and building his famous suburban houses in what was to become Levittown, it became clear that with all the new homes, flying would no longer be safe at this location. So the club owners gave in and sold the field's eighty acres to Levitt for $178,000. On March 25, 1950, the club held its last meeting. The field was evacuated by April, and before long, there was no trace of it at all, save for a road, Pilots Street, in the new development.

Chapter 6

GHOSTS OF THE GOLD COAST

There were once hundreds of grand estates along Long Island's North Shore. The so-called Gold Coast was home to some of the world's wealthiest and most powerful families, including the Vanderbilts, Whitneys, Guggenheims, Woolworths and Rockefellers. Most of these sprawling estates have since been broken up—the mansions demolished and the land subdivided. Those that remain partly intact are scattered like jewels across the island, repurposed as everything from college and school buildings (the DuPont mansion at the New York Institute of Technology and the Pratt mansion at the Webb Institute) to gardens and museums (Old Westbury Gardens and Planting Fields Arboretum).

While writing this book, I was fortunate enough to visit one of the few Gold Coast estates that are still completely intact: Erchless, the Howard Phipps estate in Old Westbury. Admiring the main house with its twenty-six bathrooms and then walking around the expansive, magnificent ninety-nine-acre grounds, I marveled at the lush, landscaped gardens. As I walked, I passed by barns, bathhouses, a tennis court, a swimming pool, a garage, stables, greenhouses, a superintendent's house, a gardener's house, a chauffeur's cottage and various other outbuildings and sheds. What struck me was the sheer enormity of the task of caring for an estate such as this, an estate inhabited by just one family—so many acres of lawns and flowers, manicured trees and carefully trimmed shrubs and walking paths and statues and sculptures, as far as the eye can see. It requires tremendous resources—manpower and money—to maintain.

The impeccably maintained Howard Phipps estate, Erchless, is one of the few intact Gold Coast properties. *Author's collection.*

The taxes on Erchless are $579,000 per year! The Phipps estate is a rarity now, but the fact that great estates just like it used to cover much of northern Nassau County is mind-boggling.

In this chapter, we'll take a closer look at the remains of some of Long Island's fascinating old estates and uncover the hidden history behind these fragments of a bygone era.

THE CURIOUS CASE OF THE THREE CASTLE GOULDS

Writing about hidden history can be quite rewarding. As I research a particular topic, I often find myself delving deeper into the back story than I'd anticipated, following a winding trail of information and uncovering strange and interesting facts. I had been to Sands Point Preserve some years ago and thought the story of the mansions there would make a good addition to this book. But when I set out to do a little more research, I got much more

than I bargained for. I returned there recently, inspired by the bizarre story that had unfolded, to soak in the sights.

What is known as Sands Point Preserve, sitting atop a bluff overlooking Hempstead Harbor in Port Washington, was once the home of two wealthy families: first the Goulds and then the Guggenheims. The buildings on the land, which was taken over by Nassau County in 1971, are described by the preserve's operator, the Sands Point Preserve Conservancy, as Castle Gould, which was the original Gould mansion (circa 1904); Hempstead House (circa 1912), modeled after Kilkenny Castle in Ireland and which Gould built as a replacement when his wife didn't like how the first one turned out; and Falaise (circa 1924), which was built by later occupants of the land, the Guggenheim family. As described, the rejected Castle Gould was then turned into stables.

So far so good. With some more detail, it had the makings of a decent story along the lines of: demanding wife rejects mansion, so husband builds her a new one. Crazy story! Except when I started to look back at old newspaper articles, nothing made sense. Not only could I not find any reference to Hempstead House, I kept encountering stories about the "unbuilt" Castle Gould. Stories from 1904 and 1905 told how the architect was suing the Goulds over their rejection of his design. How could that be? The building is right there! I kept reading, and the plot thickened. My head was spinning. Taking a deep breath, I managed to piece together the real story.

In 1900, Howard Gould, son of financier Jay Gould, purchased a large and scenic plot of land in Port Washington, overlooking Hempstead Harbor. His intent was to build a home for himself and his wife, the actress Katherine Clemmons. She didn't want just any fancy home. Her intent was to re-create Kilkenny Castle in Ireland. The couple first hired an architect named Augustus N. Allen, who laid out the estate and designed a huge stable building (said to have accommodations for one hundred horses), which took three years to build and was completed around 1904. He also proposed a design for a mansion, but that was rejected. The $4 million stable building, with its medieval-looking clock tower, was never intended to be their home and was never known as Castle Gould until about the time when the county took over the property. It is simply known as the stable. As a 1904 article proclaimed, "Those who have not been posted will believe that the magnificent pile of granite…is the castle itself." The stablemen were to be housed in thirty-two rooms on the second floor.

Meanwhile, another architect, a Louisianan and graduate of Cornell and the École des Beaux-Arts of Paris named Abner J. Haydel, was hired to

design the main house (but only after several other architects were consulted and not hired). The first order of business was accompanying Haydel to Ireland, where they could all study Kilkenny Castle and Haydel could make notes on a design that would duplicate it on an even larger scale. When Haydel returned, he set about creating plans for a two-hundred-room palace that would be the largest private residence in the world, with the largest room in the world, an orangery 2,000 feet long by 50 feet wide; a library that could hold seventy-five thousand books; and a 120-foot-long bowling alley room. There was only one problem: Mrs. Gould didn't like his plans. She rejected them not once, but nineteen times. According to a 1904 *New York Times* article, "The building of this castle has been the one great hobby of Mrs. Gould, and it was her changeful moods as to its exact dimensions, the location of this or that room, and various other details about which she and the architect differed, that have prevented the beginning of the work." The Goulds sued Haydel for $30,000 for breach of contract, and Haydel countersued for $50,000…and won in court in Mineola.

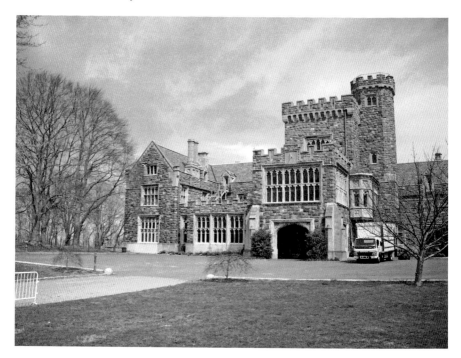

Originally known as Castle Gould, this circa 1912 mansion at Sands Point was renamed Hempstead House by its new owners, the Guggenheims. *Author's collection.*

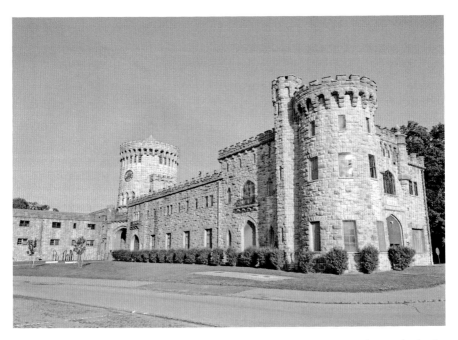

The massive Gould mansion stables at Sands Point, Port Washington, have been mistakenly called Castle Gould. *Author's collection.*

It all made sense now. Mrs. Gould didn't reject the building currently and erroneously called Castle Gould; she rejected proposed Castle Goulds. Except for one rather important question. Where did the Goulds live if their mansion was not built for all those years? They must have lived somewhere on the property. When I tried to look into this, my head started to spin again. A 1901 article refers to Mrs. Gould heading back to the Gould summer home, Castle Gould, in Port Washington. A 1904 article told of a fire that threatened their home, Castle Gould. I needed to dig deeper and located a June 1900 article that tells how Gould accepted plans for a $250,000 country home on his new property at Sands Point, designed by C.P.H. Gilbert, which would be constructed that summer. It was finished by October, when visitors, headed by a band, serenaded the Goulds as they sat on their porch after dinner. The large but not ostentatious Colonial home was known as Castle Gould until the real Castle Gould could be built. It was described as their "temporary home," which was "severely plain" but "handsome... nevertheless," while they awaited the construction of their castle. The stables, "a massive pile of stone," are described as being built to correspond in style to the proposed castle.

The Haydel suit over the design was soon overshadowed in the papers by a more interesting item—Mrs. Gould filing for divorce from her husband in 1907. The couple had not lived together since 1906. All kinds of allegations emerged during the court proceedings. Mr. Gould hired detectives (posing as coachmen and footmen) to follow his wife's every move, and they uncovered what he claimed were trysts with an actor named Dustin Farnum. He alleged that she was a drunk who had a quart of brandy a day. At one point during their separation, she allegedly removed seventy-five boxes and crates of property from their home. She also went to Tiffany's and spent $60,000 and sent her estranged husband the bill.

The rest of the story falls into place after the divorce. Howard Gould still carried on with the plans to build a castle-like mansion. A new architect was hired, even in the midst of all the marital turmoil, and a smaller-scale version of the Kilkenny Castle replica was built and completed in 1912. What is known today as Hempstead House was indeed called Castle Gould. Mrs. Gould in fact never lived in the new house, and Mr. Gould did not stay long, selling the entire property in 1917 to the Guggenheims, who renamed the main house Hempstead House and later built a new mansion on the property, called Falaise.

A PALACE WITHOUT A KING

Nestled in the heart of the 550-acre Muttontown Preserve just off Route 106 in Muttontown lie the ruins of what was once to be the palace of a king in exile. Albania's last monarch, King Zog I (born Ahmet Muhtar Zogolli, 1895–1961), had fled to England with his family in 1939 when Mussolini's army invaded. Zog was an interesting and controversial character. He had supposedly survived fifty-five assassination attempts during his political career, including one in which he actually pulled a gun and fired back at his assailants.

After Zog left England for Egypt in 1946, he had dreams of moving to America. He bought the 150-acre estate formerly known as Knollwood (built between 1906 and 1920) in 1951 for about $100,000. Rumor has it that he paid for it with a bucket of gold and diamonds. His intent was to make the thirty-room mansion (including thirteen bedrooms and eleven baths) his palace in exile, staffed by loyal Albanian subjects to cater to his every whim. But Zog never came to America, spending his remaining years in France

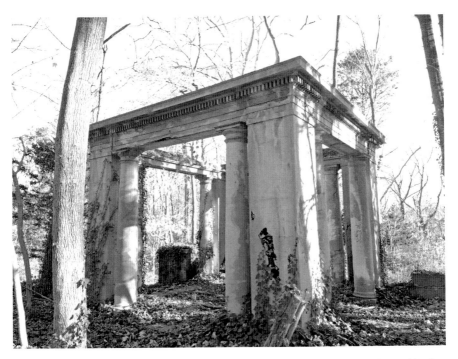

The ruins of the Knollwood estate, once owned by King Zog of Albania, are located in the woods of the Muttontown Preserve. *Author's collection.*

instead, selling the estate in 1955 to a local named Landsell Christie. The property was torn down a few years later after vandals and looters went wild trying to find the Albanian treasure that was rumored to be hidden in the mansion. The estate, along with two other neighboring estates, was soon afterward sold to Nassau County. The Muttontown Preserve was created out of the combined acreage.

What remains today of the palace-to-be are some of the garden walls, a series of steps, ruins of statuary and a spectacular columned gazebo structure, all of which have long since been reclaimed by nature. Though there are two intact Gold Coast mansions on the preserve property (Chelsea Mansion and Nassau Hall), it is the haunting remains of this one that are the most intriguing.

JOAN WAS HERE (SORT OF)

When a wealthy lawyer named Michael Gavin and his wife, Gertrude Hill Gavin (daughter of railroad magnate James Hill), had their forty-three-acre country estate, Graenan, built in the woods of Brookville in the 1920s, they hired architect John Russell Pope to design the buildings. The mansion and outbuildings were styled in a French Renaissance mode, and the façade of the mansion was said to have once been part of a sixteenth-century French chateau. There were stables, a superintendent's house, a root cellar, a greenhouse, garages, a wagon shed and a landscaped garden—pretty typical fare for a Gold Coast estate. Typical until 1926, when Mrs. Gavin decided to buy a little extra something from France to go with the mansion.

What was this little something?

Nothing less than the ancient chapel where Saint Joan of Arc once worshiped! Rediscovered in the village of Chasse, twelve miles south of Lyon, by French architect and archaeologist Jacques Couëlle, the neglected and semi-ruined thirteenth-century chapel was purchased by Mrs. Gavin, shipped to Long Island in 1927 with Couëlle's notes and reassembled, reconstructed and restored stone by stone with the help of John Russell Pope, adjacent to the Gavin mansion. (Shortly after that, the French government outlawed the exportation of architectural treasures.) Mrs. Gavin spared no expense. She even commissioned a famous stained-glass artist who'd designed the windows of the Cathedral of St. John the Divine in New York City to create four windows for the chapel.

The Gavins' reign at Graenan came to an end in 1962, when Marc and Lillian Rojtman acquired the property. The German-born Mr. Rojtman was the president of the American Tractor Company, and the Rojtmans, who collected fine paintings, must have been drawn to the European charm of the estate. To say that they were fairly wealthy is an understatement. Among their possessions was a 107-carat yellow diamond, which was among the largest of that color in the world.

Excited about their new home, the Rojtmans were all set to move in when a devastating fire swept through the mansion, destroying it in November 1962. Miraculously, the attached chapel was spared. In 1963, the fire-wrecked mansion was partially demolished, and in 1965, it was completely wrecked. Meanwhile, the Rojtmans decided to donate the chapel to the Jesuit-run Marquette University in Milwaukee, Wisconsin. It was dismantled starting in 1963, a process that took nine months to finish. The chapel was brought to Marquette by truck and reassembled in 1965.

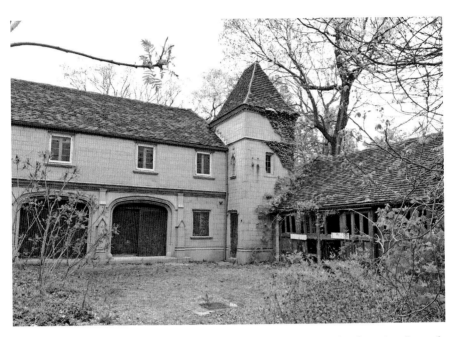

The abandoned 1920s Gavin guesthouse in Brookville. The mansion has long since burned down, and the Joan of Arc chapel on the grounds was given to Marquette University. *Author's collection.*

As for the rest of the Brookville estate, it was abandoned. Perhaps this had something to do with the fact that Mr. Rojtman died in 1967, not long after the ruins of the mansion were demolished. Mrs. Rojtman died in 2001 at the age of seventy-nine. The Rojtman estate still owns the property, and its taxes are paid from a trust fund. Several magnificent outbuildings still sit on the property, eerie reminders of the former splendor of what was once hallowed ground. Garages and stables are covered with ivy. Windows are boarded or shattered. But the sturdy stone block construction of the buildings has ensured that they remain, vestiges of an era gone by. Meanwhile, the chapel still sits proudly on the Marquette campus, a pilgrimage and reflection site for students, faculty and pilgrims from all over.

PEACEFUL GARDENS, PEACEFUL WORLD

Adjacent to railroad tracks and surrounded by homes and shopping, the twelve-acre Clark Botanic Gardens in Albertson is touted as an oasis of

tranquility where rabbits, chipmunks, turtles, toads and frogs roam freely in and around several ponds and streams and amid the flowers and paths. Founded in 1969, this property was formerly the estate of Grenville Clark, a very hidden but highly powerful player in American twentieth-century history. Though he never held public office, this wealthy and influential lawyer was honored on a thirty-nine-cent postage stamp in 1985.

Why? Who was Grenville Clark?

Clark, a wealthy, Harvard-educated attorney, had a part in several key moments starting in September 1901, when President McKinley was shot. At the time, Vice President Theodore Roosevelt was on a friend's yacht on Lake Champlain, and an eighteen-year-old Grenville Clark, who was summering in Burlington, Vermont, was the one selected to deliver telegrams on McKinley's condition to Roosevelt.

While World War I raged in Europe, Clark promoted military preparedness in an era of American isolationism, helping found the Plattsburgh Plan, a program that trained sixteen thousand professional men to become army officers in 1915, two years before the United States entered World War I. He wrote the Selective Service Plan in 1940, more than a year before the nation entered World War II, and helped get it passed in Congress. During World War II, Clark served as Secretary of War Henry Stinson's personal advisor.

In the postwar era, Clark was a behind-the-scenes player in the development of the United Nations and was a big proponent of world peace and nuclear disarmament. In 1958, he wrote a book called *World Peace Through World Law*. He was also a proponent of civil rights, raising $80,000 for bail money for the defendants in the Montgomery and Birmingham "freedom ride" cases. When he died, he left $500,000 to the NAACP. Despite his postage stamp and his gardens, his name and his story remain hidden to this day—his 2014 biography is titled *A Very Private Public Citizen*. Even those who visit the Clark Gardens will not encounter his name, because when he died in 1967, Clark left his Albertson property, which he'd owned since 1920, to become a public garden in memory of his late wife, Fanny Dwight Clark. The peace of these modest yet spectacular gardens is a perfect metaphor for Clark's life.

TIFFANY'S LAST STAND

Louis Comfort Tiffany (1848–1933) was a brilliantly creative man who designed some of the most incredibly vivid and beautiful stained glass

and jewelry in American history. His pieces found their way into the most prestigious churches and public buildings in the country and into the collections of museums and wealthy individuals. But his flair for elegant and luxurious design did not stop at windows and lampshades. When he decided to purchase six hundred acres on Long Island's North Shore in the village of Laurel Hollow in Suffolk County at the turn of the twentieth century, he planned an ornate mansion of epic proportions atop a hill overlooking the harbor. The building had eighty-two rooms, with twenty-six bathrooms. The exterior featured extensive glass mosaic and decoration.

Unlike most mansions of the time, the Tiffany home, Laurelton Hall, had no fireplaces, because Louis Comfort Tiffany was afraid of a fire starting. Instead, he had a coal-heating plant built on the property, which would burn coal and heat the enormous home. But for such a large building, a large heating plant would be required. And burning coal on that scale would require a fairly substantial smokestack, which could potentially be an eyesore for his neighbors.

The Tiffany Tower at Louis Comfort Tiffany's Laurelton Hall estate, seen in 1924, still stands today, the last remnant of a once magnificent estate. It served as a smokestack. Colorful Tiffany glass can be seen at its apex, glinting in the sunlight. *Library of Congress.*

However, in typical Tiffany style, he did not settle for the ordinary or the ugly. No, Tiffany's sixty-foot-high smokestack was an ornate affair, an attractive tower with a top looking much like a minaret and with blue stained-glass panels enshrined by pairs of columns just under its peak.

Tiffany became an important figure in the local community, founding an art school on the property in 1915. After he died in 1933, the foundation he had started continued to operate until 1946, when the property was sold and the building abandoned.

The mansion burned down in 1957, probably due to vandals. It was a disastrous conflagration, and there was little left of the palatial home after the flames were out. Some marble columns, tiles and stained glass was salvaged and sent to a museum in Florida. The land has since been sold and subdivided. Today, there are scant few remnants of the glory that used to be the Tiffany estate. The most visible one can be seen only from a few remote vantage points.

Ironically, the smokestack of the coal-burning plant down the hill and away from the main building, which existed precisely because there were no fireplaces, was the only survivor of the fire. A drive to the end of Laurel Hollow Road leads one to the village hall and a small beach. (In fact, when I visited the site, I found a fist-sized hunk of coal along the beach, no doubt a remnant from one of Laurelton Hall's coal deliveries over seventy years ago.) It is from here that the gorgeous smokestack can be viewed. The blue stained glass glimmers in the sunlight, a reminder of the artistic mastermind who once lived on that spot.

HARBOR HILL WATER TOWER

Heading north on Roslyn Road through East Hills, on your right at the corner of Harbor Hill Road, you'll see a beautiful French Baroque–style gatehouse that seems to lead nowhere. What is this mysterious old structure? Now it is just a sad remnant, but it was once nothing less than the grand entrance to the driveway of a vast six-hundred-plus-acre turn-of-the-twentieth-century estate called Harbor Hill. The estate's epic 266-foot-wide mansion (one of the largest homes in the country) was perched upon the highest hill in Nassau County (348 feet above sea level) and belonged to the wealthy financier Clarence Mackay (1874–1938), who was chairman of the board of the Postal Telegraph Cable Company.

The Harbor Hill water tower, tucked away in a residential neighborhood, is one of the last remnants of the huge Clarence Mackay estate in Roslyn. *Author's collection.*

The colossal Mackay mansion was designed by the famous firm of McKim, Mead & White, and the landscaped grounds and gardens were by all accounts magnificent. Guests who were entertained there included the Prince of Wales, F. Scott Fitzgerald and Charles Lindbergh—just two days after his triumphant return to the United States in 1927. Yet

despite all the splendor, the mansion's life span was less than fifty years. Harbor Hill was abandoned in 1938 after Mackay's death because his son could not afford the upkeep. It was demolished in 1947 and the land sold and subdivided.

But the gatehouse is not the only remnant of this immense estate. Turn left onto Harbor Hill Road and then left again into a development called Country Estates and you will come upon one more remnant off of Redwood Drive—an ancient-looking stone tower! But what is it?

Such a vast estate (it employed 180 people at its peak) required a great deal of water, but at the time there was no organized water district in the area, so the estate would have to include its own water distribution system. Stanford White (of McKim, Mead & White) was called upon to design an aesthetically pleasing structure in which to encase and disguise the otherwise ugly sixty-five-thousand-gallon water tank. Located as it was at a high point, the water distribution system relied on gravity to send water through a system of pipes to the mansion and other buildings on the property. White designed a quaint, sixty-five-foot-high, thick-walled stone tower that looks like it belongs to a medieval European castle, in whose window at any moment a damsel in distress might appear calling for help.

When the mansion was demolished, the water tower remained because it could serve a function and provide water to residents of Roslyn, but the tank eventually wound up inactive. It's currently a spare tank, ready to be put into use in case it's needed. It is one of the last remnants of one of the most impressive estates ever built.

THE WHITNEY TOWER

In 1960, 190 acres of what was once the 530-acre William C. Whitney estate in Old Westbury were sold to a group looking to create the Old Westbury Golf Club (which opened in 1962). Nestled amid the club's grounds is an impressive sight—a 187-foot, ten-story tower designed by noted architect Stanford White in 1898 as part of a water system for the original Whitney manor house, which was built in 1902. The tower (rumored to be haunted by the ghost of a young man who jumped from it to his death) was originally a windmill and used to draw water for the estate from a 587-foot-deep well. A young Gloria Vanderbilt lived on the estate

The Whitney estate water tower was built in 1898. It now stands on the property of the Old Westbury Golf Club. *Author's collection.*

for a time; Mrs. Whitney was her aunt. During World War II, the tower was used to watch for enemy aircraft. Restored by the club in 1963, it is now used for storage. The estate's mansion is now the clubhouse, which can be seen from Wheatley Road.

Chapter 7

FINAL RESTING PLACES

L ong Island's earliest cemeteries were either churchyards, town burying grounds or private family cemeteries. As the nineteenth century progressed, Long Island's population was growing rapidly, and more space was needed to bury the dead. Large, sprawling cemeteries began to spring up on open land around the island, including several clustered along Wellwood Avenue in Farmingdale. Among them are the massive 1,000-acre Pinelawn Memorial Park in Farmingdale, the 580-acre St. Charles Cemetery (Long Island's largest Catholic cemetery) and the 356,000-burial Long Island National Cemetery for veterans (Long Island's largest full cemetery). In this chapter, we'll explore a mix of some of Long Island's interesting cemeteries.

HUNTINGTON'S OLD BURYING GROUND

Huntington is a cool Long Island destination, with a thriving downtown and great shops and restaurants, as well as an excellent nightlife, spotlighted by a fantastic concert venue. Yet Huntington, for all its life, is also the site of one of the island's most amazing resting places for the dead. The Old Burying Ground in Huntington lies just east of downtown, on a hill on the south side of Main Street. Dating to 1657, with the first death of the newly formed town, it is one of Long Island's oldest cemeteries. It also has some of the best-preserved and most interesting eighteenth-century

An aerial view of Long Island National Cemetery in Farmingdale, 1960. *Library of Congress.*

gravestones on Long Island. The earliest markers were made of wood and so are long gone, but the oldest legible dated stone dates impressively from 1711, and there are quite a few stones with dates in the mid-1700s. In 1782, during the British occupation of Huntington (ongoing since 1776), the British ordered the construction of a fort atop the Burying Ground. Town residents were livid over this desecration. How dare the British build a fort on this hallowed ground! Not only that, but at least one hundred gravestones were ripped out of the ground in the process, many of them used in bread ovens for the British soldiers. The fort was abandoned in 1783 and finally removed in 1784. The cemetery continued to be used into the late nineteenth century but was rarely used by the twentieth century. The last burial there occurred in 1957. As with many smaller cemeteries, this one suffered from neglect. It was cleaned up starting in 1911 and underwent a major restoration in 2004.

There are cool poems on some of the gravestones, including these:

1749:
Behold and see as you pass by
As you are now so once was I
As I am now so you must be
Prepare for Death and follow me.

1750:
Here I lye and you that read
Must to the silent grave succeed
For youth and Vigor Death demands
…Earth its terrors still withstand

1764:
To this sad Stone whoe'er thou art
* draw near*
Here lies the Youth most lov'd the Son
* most dear*
Who ne'er knew joy but friendship
* might divide*
Or gave his father Grief but when he
* dy'd.*

1810:
Like as a shadow or the morning dew
My days are spent which were but few
Grieve not for me my friend so…it is in vain
Your loss I hope is my eternal gain

A gravestone dating to 1749 at Huntington Burying Ground. *Author's collection.*

UNDERHILL BURYING GROUND

In the village of Locust Valley on Nassau County's north shore, we find a very historic burial ground, one of the island's oldest. Its namesake, Captain John Underhill, was one of the most fascinating and accomplished early settlers of Long Island. Born in England in 1597, he came to this country around 1630 and was hired by the Massachusetts Bay Colony. Among other things, he was governor of New Hampshire. In 1654, Underhill moved to Long Island, first to Setauket and then to Matinecock. He also led attacks

against the local Native Americans, notably one at what was then called Fort Neck, now called Massapequa.

I set out to find the Underhill Burying Ground after having read about its existence. A pleasant and leisurely drive up to Locust Valley, along meandering and hilly roads, took me to Factory Pond Road, just off of which my map told me I would find the cemetery. Well, I found it all right, or the entrance to it, at least. The cemetery proper is located on a hill on the west side of the road. The entrance is marked by a gate with a "No Trespassing" sign and a boulder upon which is mounted a bronze plaque. I thought about whether or not to tempt fate and take a quick peek by walking up what appeared to be a deserted pathway to the cemetery at the top of the hill. This was history that was truly hidden.

I love to explore, but that sign gave me pause. I decided at least to photograph the plaque—visuals are always good. I turned on my camera, got into position and set up my shot, pressing down halfway to get the picture in focus. The only problem was that there seemed to be a glare or something in the image on my display screen—a circular spot of brightness.

A mysterious orb on a photograph taken by the author of a plaque marking the Underhill Burying Ground. *Author's collection.*

I tried refocusing. Still there. I looked at the plaque—no glare there, no rays of sunlight anywhere near. Strange, and annoying! I moved the camera up and down slightly, but the circle of brightness did not move. I looked at the lens. I tried taking a photograph, thinking maybe it would not appear in it. The result is shown here. Still, at the time, I was thinking it was some trick of light. A minute later I tried again, and the circle was gone. Only after I got home and looked closely at the photograph did I fully realize the impossibility of that circle being a natural phenomenon. It's not as if the circle was only on my screen. It was in the image yet not on the plaque. I cannot say what it was or how it happened, but it sure was bizarre. Note, too, that the circle falls directly on the "hill" part of his name, which I also found rather eerie. I've not read anything about the cemetery being haunted—but now, who knows!

GREENFIELD CEMETERY

A walk through Greenfield Cemetery in Uniondale, referred to in a 1920 newspaper article as Hempstead's "Beautiful City of the Dead," reveals a nice mixture of old and new gravestones. You'll see many weathered stones with dates going back to the 1850s and earlier. Interesting, but even more so considering the cemetery was only founded in 1870! How did this happen? Let's go back to the beginning to understand what led to this strange phenomenon.

The first Hempstead town cemetery was located on the western edge of the Hempstead Plains in what is now Garden City. When A.T. Stewart bought thousands of acres of land and began to develop Garden City, he realized that the old cemetery was in the way and would have to go. But how? He had an idea. He purchased twenty-five acres of a farm belonging to Judge Dikeman on land south of Hempstead, east of Garden City, and gave it to the town for use as a cemetery. Thus was born Greenfield Cemetery. In 1870, all 74 of the bodies buried in the Garden City location were moved to Greenfield. This happened at least several more times as the population of the town grew. In 1900, for example, 20 bodies from the Smith burying ground in Freeport and 13 bodies from the Powell family cemetery in Freeport were moved to Greenfield. In 1922, a huge reburial undertaking began, when 1,000 bodies were moved from the old Freeport cemetery to Greenfield to allow Freeport to build a high school. And in 1928, 250 bodies

The three gravestones in the foreground and their accompanying bodies were moved to Greenfield Cemetery, along with hundreds of others. *Author's collection.*

were removed from the Hempstead Presbyterian Church cemetery on Front Street so a new church could be built on the site.

Greenfield has a few more interesting distinctions. First, it is the only cemetery of its kind in New York State, owned and operated by the town itself; only residents of the Town of Hempstead can be buried there. Among those who are buried there is George Washington Freeman Horner Green, who died at the Hempstead almshouse in 1900 at the reputed age of 123! Born in 1777, Green was said to have been one of George Washington's slaves before being freed in 1812 and making the trip north to Long Island. Greenfield is also the final resting place for baseball hall of famer John Montgomery Ward (1860–1925) and former New York City mayor Daniel Tiemann (1805–1899). From its original 25 acres, the cemetery has expanded to 158 acres. By 1915, there were nine thousand burials there; by 1932, there were twenty thousand burials at the cemetery. As of 1998, there were more than eighty-two thousand interments.

YOUNGS MEMORIAL CEMETERY

Founded in 1658 (one account says 1647) by a family of English immigrants who arrived on Long Island in 1640 and soon after settled in Oyster Bay Cove, the privately owned Youngs Memorial Cemetery is one of Long Island's oldest. Perched on a hillside on Cove Road, just east of downtown Oyster Bay, the cemetery is known for more than just its fine views of the cove and its weathered eighteenth- and nineteenth-century gravestones. Always a local landmark, this graveyard achieved national fame on January 6, 1919, when former president Theodore Roosevelt died suddenly at his Sagamore Hill home just down the road. Newspaper stories describing the arrangements told how the Roosevelts had purchased plots in Youngs Memorial Cemetery about seven years before. The quaint old Long Island cemetery was about to change forever. Why had the Roosevelts picked Youngs as their final resting place? Roosevelt's father had purchased the Sagamore Hill land from the Youngs family just after the Civil War, and William Jones Youngs (1851–1916) had served as Roosevelt's secretary while he was governor of New York.

At 11:00 a.m. on January 8, a black hearse arrived at Sagamore Hill to retrieve the president's silk flag–draped casket. The procession made its way to Christ Church in Oyster Bay for a simple funeral service (without any music). The church's Christmas decorations still remained in place. The procession then headed for Youngs Cemetery, where the coffin was carried uphill to its final resting place in a plot about sixty feet from the top of the hill by six pallbearers selected by the undertaker. (Interestingly, Roosevelt had, on more than one occasion, expressed his wishes not to have honorary pallbearers.) There had been a brief service at Sagamore Hill for the benefit of the grieving Mrs. Roosevelt, who did not attend the funeral or burial.

For the minute between 1:59 p.m. and 2:00 p.m., New York City came to a grinding halt as New Yorkers observed a minute of silence while President Roosevelt's silver-handled oak coffin was lowered into the snow-covered cemetery ground. Automobiles stopped, the power to the subways and Long Island Rail Road was turned off, factory machines fell silent and schoolchildren sat quietly. Tens of thousands of New York City policemen removed their hats in tribute, and hundreds of church bells around the city tolled. One newspaper article of the time proclaimed, "Roosevelt's Final Resting Place Simple and Rugged as the Man Himself; Grave Located Near Those of an Unknown Child and Former Slaves of the Youngs Family."

Theodore Roosevelt's grave in the Youngs Memorial Cemetery in Oyster Bay. *Author's collection.*

The cemetery is generally open to the public daily, and the president's grave site can be reached via twenty-six steps (in honor of Roosevelt being the twenty-sixth president) after a walk uphill along a paved pathway. From the moment Roosevelt was buried there, Youngs Cemetery instantly became a popular destination. A July 1919 newspaper article tells of "pilgrims from

every state and many foreign lands" who flocked to the cemetery. In those first months after his burial, souvenir hunters snipped pieces of ribbon from memorial wreaths and gathered scoops of the hallowed dirt that had been excavated to make Roosevelt's grave (until there was nothing left but a few pebbles). Some of the souvenir hunters were former Rough Riders who served under Roosevelt in Cuba. The flow of people continues to this day. (The grave is now surrounded on all sides by an iron fence to prevent vandalism.) When I arrived on a Saturday afternoon in the spring, I was the only one there, but soon after, several other cars pulled up and at least a dozen people streamed in, all making the vigorous climb up to Roosevelt's grave site. One older gentleman stood at the grave giving a detailed explanation to two younger men of how Roosevelt came to marry his second wife, Edith, after the death of his first.

Mrs. Roosevelt, who died in 1948, is buried with her husband, and numerous other Roosevelt family member graves can be found in the section of the cemetery behind the president's grave, including that of Roosevelt's daughter Edith and his son Kermit, as well as lots of Roosevelt cousins. The Roosevelt family later bought up land adjacent to the cemetery to create the Theodore Roosevelt Sanctuary for birds.

HOME OF THE FUTURE DEAD

In chapter 4, I told the story of the Hitchcock family, polo pioneers. In this chapter, I will tell the story of the now-abandoned Hitchcock estate, which is fascinating in its own right. The tale of the ninety-seven-acre property that lies just north of Jericho Turnpike in Old Westbury, between Hitchcock Lane and Powells Lane, is a long and fascinating one whose ending is yet to be determined. It sounds almost too bizarre to be true: the former estate of the world's greatest polo player, which sits abandoned and dilapidated in the heart of Nassau County, may one day serve as a final resting place for tens of thousands of Long Islanders. Where once horses galloped happily through fields, a sea of gravestones could eventually stretch out in solemn rows as far as the eye can see.

The story begins with the very first settlement of Westbury in the 1660s. The Hitchcock estate was part of land under the original seventeenth-century deed of Edmund Titus, who came here from England in the 1660s. For more than two hundred years, much of the area of what is

now Old Westbury and Jericho remained tranquil farming communities. Quiet Quaker farms dotted the peaceful, rolling landscape. But things began to change in the nineteenth century, when the railroad came to town. Suddenly this pleasant area was noticed by many of the wealthiest families in New York City. It was convenient to the city, near a railroad station that could whisk them off to their city homes in an hour's time. When they looked at these Quaker farms, they saw magnificent country retreats. And once the first few began to build, it was a free-for-all. The wealthy began buying up the old farms and building gigantic, lavish mansions, equipped with all the luxuries of the day. Though most of the wealthy estate owners demolished the old farms and had their own new homes built, a few decided to utilize the existing farmhouses on the property. Thomas Hitchcock chose the latter option, perhaps because he was a Westbury native and was moved by the sentimental charm of the old building. Hitchcock and his wife had the old house remodeled and expanded in 1892–93 by noted architect Richard Morris Hunt.

As of 1910, Thomas Hitchcock Sr. employed a staff of twenty-one on his estate, including a nurse, butler, bellboy, seamstress, coachman, groom, stable boy, chambermaid, laundress, waiter and housekeeper. According to *Sportsman* magazine in 1929, Broad Hollow house was "one of the most reposeful, inviting and altogether delightful on Long Island, sitting among ancient silver maples and locusts, smiling out over the broad expanses of hay land on which Mr. Hitchcock raises the hay for his many race horses." But the sudden deaths of Hitchcock Sr. in 1941 and then Hitchcock Jr. in 1944 sealed the fate of the property, leading to the Catholic Church buying it at a bargain basement price at an auction in 1995.

Why on earth would the Catholic Church want to buy a large, run-down estate? The answer is quite simple: it saw dead people. The diocese, running out of room for burials in its three cemeteries, desperately needed more space. Its only cemetery in Nassau County, Holy Rood, was full. But where could a large enough plot of undeveloped space be found in Nassau County? To the church, this seemed like a match made in heaven. On the ninety-seven acres of mainly fields, easy to access just off Jericho Turnpike, the church envisioned ninety thousand plots where the horses once frolicked. It would be called the Queen of Peace Cemetery. The cemetery would sit on the southernmost seventy acres, where the racetrack was. The northern twenty acres would contain a residential development—necessitating the demolition of all the existing buildings, including the old homestead and the famous stables.

The former Thomas Hitchcock racetrack is slated to become a cemetery if the Diocese of Rockville Centre gets its wish. *Author's collection.*

While the diocese was thrilled, there were plenty of folks in the community who were disappointed with this sale. In an article following the sale, the Old Westbury village mayor was quoted as saying she had hoped some "horseman would take it."

While the diocese was hopeful at the start, drafting plans to show the village in 1995, things soon took an ugly turn. Village officials rejected the cemetery as not to code. Thus began an epic battle that has been waged for the last twenty years. Lawsuits were filed and counter-filed. Arguments were made and remade. Zoning laws were picked apart line by line. Both sides have come at each other with more demands and restrictions. For example, the village has maintained that the pond on the property must be preserved and protected. The village has called for this pond, which goes back at least three hundred years and was once known as Great Pond, to be surrounded by a seventy-five-foot buffer zone.

The diocese continues to argue that the cemetery will be a "religious use" of the land rather than a commercial one, which would allow it to proceed. The village disagrees. In addition, environmental concerns have been raised

based on the property's location within one of the county's two groundwater protection areas. Fears were raised that contaminants from the embalming process might seep into the groundwater, but tests on other local cemeteries have indicated that this is not an issue.

The latest step in the war happened at the end of 2015, when a legal ruling said that some of the village's objections were baseless. This opens the door for the diocese to take further legal action.

In the meantime, the abandoned old estate sits quietly, awaiting its fate. The handsome mansion, which contains within its core one of the oldest Quaker buildings on Long Island, now sits crumbling, its windows broken, its ornate wooden trim falling apart and its façade hidden by untamed vines and shrubs.

Selected Bibliography

Curtiss, Glenn H., and Augustus Post. *The Curtiss Aviation Book.* New York: Frederick A. Stokes Company, 1912.

Dalton, Sir Cornelius Neale. *The Real Captain Kidd: A Vindication.* London: William Heinemann, 1911.

Denton, Daniel. *A Brief Description of New York (Formerly Called New Netherlands).* New York: William Gowans, 1845 (reprint of 1670 edition).

Frothingham, Jessie Peabody. *Sea Wolves of Seven Shores.* New York: Charles Scribner's Sons, 1904.

Hill, Nancy Peterson. *A Very Private Public Citizen: The Life of Grenville Clark.* Columbia: University of Missouri Press, 2014.

Hotaling, Edward. *They're Off: Horse Racing at Saratoga.* Syracuse, NY: Syracuse University Press, 1995.

Kroplick, Howard. *Vanderbilt Cup Races of Long Island.* Charleston, SC: Arcadia Publishing, 2008.

Kroplick, Howard, and Al Velocci. *The Long Island Motor Parkway.* Charleston, SC: Arcadia Publishing, 2008.

Laffaye, Horace A. *Polo in the United States: A History.* Jefferson, NC: McFarland & Company, 2011.

Onderdonk, Henry, Jr. *Revolutionary Incidents of Suffolk and Kings Counties.* New York: Leavitt & Company, 1849.

Ovington, Adelaide Alexander. *An Aviator's Wife.* New York: Dodd, Mead and Company, 1920.

Panchyk, Richard. *Forgotten Tales of Long Island.* Charleston, SC: The History Press, 2008.

————. *A History of Westbury, Long Island.* Charleston, SC: The History Press, 2007.

————. *101 Glimpses of Long Island's North Shore.* Charleston, SC: The History Press, 2008.

————. *101 Glimpses of the South Fork.* Charleston, SC: The History Press, 2009.

Smith, M.H. *Garden City, Long Island in Early Photographs, 1869–1919.* New York: Dover Publications, 1987.

Smits, Edward J. *Nassau: Suburbia, U.S.A.: The First Seventy-Five Years of Nassau County, New York, 1899–1974.* Garden City, NY: Doubleday, 1974.

Tabler, Judith. *Foxhunting with Meadow Brook.* New York: Derrydale Press, 2016.

Velsor, Kathleen. *The Underground Railroad on Long Island: Friends in Freedom.* Charleston, SC: The History Press, 2013.

Wallhauser, Henry T. *Pioneers of Flight.* Maplewood, NJ: Hammond Incorporated, 1969.

Weidman, Bette S., and Linda B. Martin. *Nassau County, Long Island in Early Photographs, 1869–1940.* New York: Dover Publications, 1981.

Williford, Glen, and Leo Polaski. *Long Island's Military History.* Charleston, SC: Arcadia Publishing, 2004.

INDEX

About the Author

Richard Panchyk knew he wanted to be a writer by the time he was seven years old. He made his first sale, a four-page handwritten trivia booklet written on a folded piece of looseleaf paper in runny blue ink, to a third-grade classmate for a nickel. A native of Elmhurst, Queens, Richard attended the prestigious Stuyvesant High School, where he took a class on the history of New York. He has been fascinated by the area's past ever since. He printed a small book of his poems at the age of nineteen and published his first book at the age of twenty-one. Since then he has published twenty-seven books for a total of more than three thousand pages, including five titles on Long Island's history and seven titles on New York City's history. His first book for The History Press was published in 2007.